First Edition

The author is grateful for permission to reprint the following copyrighted material:

Excerpts from <u>The Art Spirit</u> by Robert Henri. Renewal copyright ©1958 by Forbes Watson. Used by permission of HarperCollins Publishers.

Excerpt from <u>The Untouched Key</u> by Alice Miller. Translation copyright ©1990 by Alice Miller. Used by permission of Doubleday, a division of Bantam Doubleday Dell Publishing Group.

Excerpt from <u>Start Over Every Morning</u> by Harvey Jackins. Copyright ©1989 by Harvey Jackins. Used by permission of Rational Island Publishers.

Excerpt from <u>Revolution from Within</u> by Gloria Steinem. Copyright ©1992 by Gloria Steinem. Used by permission of Little, Brown and Company.

Library of Congress Cataloging in Publication Data

Ascone, Teresa, 1945-
 We're all artists : watercolor for everyone / by Teresa Ascone.
 p. cm.
 Includes index.
 ISBN 1-883724-00-7 : $19.95
 1. Watercolor painting--Technique. I. Title.
 ND2420.A83 1994
 751.42'2--dc20 93-8901
 CIP

Printed in the U.S.A.

ISBN 1-883724-00-7

Lay-Flat Ota Binding: This book will lay open. Press along the length of the spine with the book open to crease back the page. The binding is resilient and durable; it will stand up to years of repeated use.

ACKNOWLEDGEMENTS

Heartfelt appreciation to:

 Mike, Michael and Kelley

 Bea Palmer

 Neva Harnish

 Janette Kasl

 Glo Godfretsen

 Ann Chandonnet

 Cathy McMenamy

 Carolyn Unger

 Luella Sutherland

 my students: past, present and future

Special gratitude to the Turbo Group: Jan C., Linda S., Vonni C., Susan H., Ginny D., Diane S., Jane G., Patty B., Susan M., Julie H., Marybeth B., Darlene W., and of course, Kay R., wherever you are.

to the artist in YOU

PREFACE

"...why do I and so many others grow up believing that painting is a never-never land from which non-Artists are forever barred? Perhaps it has come with the long separation of art from daily life, and the denigration of useful art as 'crafts'...For whatever reasons, using paint, crayons, and clay has become something many of us do before we're old enough to read and write - and then abandon...we need to use <u>all</u> of our senses if we are to value all of ourselves."

- <u>Revolution from Within</u> by Gloria Steinem

Gloria Steinem's words illustrate how often most of us unconsciously sever the connection with that which is creative and playful in ourselves in order to grow up. We are urged to pursue more serious activities - we are encouraged to "put away childish things." The assumption that artistic expression is a waste of time or childish is a mistaken one. In these stressful times, we need a way to release the anger and tension that gather inside us and, left there, erode our sense of well-being and threaten our emotional and physical health.

Inside all of us, waiting to re-emerge, is a creative, playful and joyous being. It's time to consciously reconnect with this creative self that has lain dormant for too long. It is within our power to reclaim access to this creative spirit - you can start NOW! Join the revolution.

*"Art when really understood is the province
of every human being."*

\- <u>The Art Spirit</u> by Robert Henri

INTRODUCTION

Welcome! This is a book about watercolor; it may be the first one you've read on the subject. My mission is to provide a step-by-step method for painting, to help you access the creative, imaginative spirit that has been hidden inside you; a spirit that, I believe, is hidden inside everyone - hence the title to this book.

"The real study of an art student is more a development of that sensitive nature and appreciative imagination with which he was so fully endowed when a child, and which, unfortunately in almost all cases, the contact with grownups shames out of him before he has passed into what is understood as real life."
- The Art Spirit by Robert Henri

We quickly learn to hide our more creative selves when we suffer ridicule as children: from peers, teachers, and parents. The creative impulse is a tender, fragile thing that must be nurtured and protected if it is to grow with confidence. Harsh or hasty judgment, which most of us endure, withers creativity and independent thinking.

"Creativity is so delicate a flower that praise tends to make it bloom while discouragement often nips it in the bud."
- Alex F. Osborn

I once heard a story about a young elementary student who was banished to the hall for putting a round door on a house he'd drawn, instead of a traditional rectangular-shaped one. That's the kind of shaming, censorious action that stifles creativity and makes people stick to stereotypes when they express themselves.

My vehicle of choice for this "quest for creativity" is watercolor painting. It is wonderful! From the very first time I began painting in watercolor, I was fascinated. When the paper was wet, I'd apply bright, juicy colors and the colors would swirl and spread as if by magic. The variables of watercolor are somewhat predictable - but also infinite and unexpected. With different techniques, you can get wonderful textural effects, and hard or soft edges.

The first lessons in this book approach the art of watercolor by painting within the framework of prepared compositions. Later, advanced lessons prepare you for more autonomy and freedom of expression. Just as you cannot write an essay in a foreign language until you have mastered the language, it is difficult to paint a dynamic and expressive watercolor without learning the basic techniques that will expand your painting "vocabulary." This is the time to develop your technical skills so that later you can concentrate on personal expression. My task is to teach you these basic techniques, much as I was taught them from a variety of gifted teachers.

I hope you will PRACTICE these skills while using this book as a reference tool, because practice (much like running the scales in piano) is one of the essential keys to success in watercolor. It has been said that one must paint a hundred watercolors before one feels comfortable in the medium. That is no exaggeration.

This book deals primarily with watercolor techniques. Please remember that technique is an important tool, but not the only element for exploration; if you decide to pursue more information about composition, perspective, or numerous other elements of painting, consult your library for a wealth of material on art and creativity.

Above all, don't be too hard on yourself if you can't seem to absorb these methods right away. Some of the techniques are difficult and require practice before mastery, so be patient and uncritical with yourself. Go with the flow.

The lessons contained in this book are proven learning methods that I developed specifically for my students. I have been using these lessons in workshops for more than ten years, introducing hundreds of awakening artists of varying ability to the thrill of painting with watercolor. Feedback from students over the years has helped me sharpen my teaching skills and streamline the lessons for maximum effectiveness.

Again, welcome. And congratulations for venturing into the mysterious and rewarding realm of watercolor!

WE'RE ALL ARTISTS: Watercolor for Everyone

by *Teresa Ascone*

Alaskan Portfolio Press

P.O. Box 241453
Anchorage, AK 99524-1453

TABLE OF CONTENTS

CHAPTER FOUR: Intermediate Paintings, Step by Step

CHAPTER FIVE: Permission to Play

CHAPTER SIX: Advanced Watercolor Painting

*"Whatever you can do, or dream you can, begin it.
Boldness has genius, power, and magic in it."*

- Goethe

CHAPTER ONE

HELPFUL HINTS AND PRELIMINARY STEPS

DEFINITIONS
OF BASIC TERMS

Aerial Perspective: To portray distance and depth, use grayed color, lighter value, overlapping shapes, and smaller relative size. Foreground objects are generally warmer in tone, more distinct or hard-edged, and usually brighter or darker in color.

Blending Off or Feathering (graded wash): Fading color off gradually, from dark to light, taking care that a hard line does not form in the wash.

Bloom or Back-run: Blooms appear as hard edges inside or on the edge of a wash. Sometimes they can be useful, such as in the portrayal of distant foliage, etc. Blooms result when the added water from a subsequent stroke runs back into the initial or previous wash. The previous wash is dryer; hence the hard line when the water pushes the color back.

Contrast: A dynamic opposition of shapes, colors, value, or objects that are basically different.

Feathering: See Blending Off.

Graded Wash: See Blending Off.

Hair Dryer, Blow Dryer: Can be used to hasten drying of your painting. Always use the dryer on "cool" setting. Wait until the color sinks into the paper before using a blow dryer. A good way to tell if your paper is dry enough to continue is by touching it with the back of your hand. Damp areas are cool to the touch.

Linear Perspective: A way of placing objects in space as they would appear to the viewer from a given vantage point. Linear Perspective is not addressed specifically in this book.

Lost and Found Line: This principle follows the theory of "suggestion rather then declaration", where a passage is more sharply defined, then "lost", or faded; the passage continues as "understood" by the viewer. This principle is often applied for objects in background that are supporting players in your painting, or in the soft and hard edges

depicted as you paint an object, to make parts of the object advance (hard line) or recede (soft, lost line).

Maskoid, Use of: Maskoid can be useful for areas of a painting where white areas are to be protected while wet washes are allowed to run over the area. The area is masked, then the washes are applied. After the paper is completely dry, the mask is removed and clean paper is underneath. Maskoid can be applied with a number of tools: a wooden matchstick, cotton swab, or a watercolor brush. Special effects can be achieved by spattering it with the toothbrush or applying it with a pen nib. Care must be taken to protect your watercolor brushes while using maskoid. The brush should be protected in the following way:

1. Wet a bar of soap (or use liquid soap) for suds. Thoroughly coat the brush with suds, making sure the soap penetrates into the bristles.

2. Gently squeeze off excess suds, and dip the brush into the maskoid, applying it to the paper. If you are masking a large area, it may be necessary to rinse the brush and reapply the soap once or twice.

3. After you've finished with the mask, soap and rinse the brush several times to make sure no maskoid remains.

Monochromatic Painting: A painting done in one color; the painting can include a full range of dark to light in that one color.

Negative Painting: Negative painting describes the technique of making a shape appear by applying color around the shape, right up to the edge of it.

Non-staining pigment: A pigment that can be easily lifted or removed from the paper by gentle scrubbing.

Palette: A white tray with small wells for storage of colors and large mixing areas, such as: Robert Woods palette or Pike Palette.

Paper: I recommend using d'Arches Cold Pressed or Rough, 140# or 300# paper. The heavier weight (300#) does not need to be stretched, whereas the lighter weight (140#) should be stretched to reduce buckling while wet. D'Arches paper is sturdy and holds up well for the techniques

described in this book. The designations refer to paper texture:

Hot Pressed = smooth texture

Rough = bumpy surface

Cold Pressed = between Hot Pressed and Rough:
somewhat bumpy

Photographs, Use of: I fully endorse the use of your own photographs as inspiration or reference for paintings (Using photos from books, post cards, magazines, or other sources, then affirming that your painting is "original", could be a copyright infringement). Capturing light effect, a sunset, or a fleeting movement is difficult to do without the use of a camera to "freeze" the color and action of the moment.

Picket Fence Effect: Term used to describe painting objects (trees, rocks, etc.) in a "police line-up" - too evenly spaced, too much the same shape or size. Can promote monotony and a boring composition. On the other hand, when used deliberately, can communicate the intent of the artist.

Salt Technique: Gives a textural effect; appearance can range from small dots to larger ones, depending on relative dampness of the wash. To use this technique, lay down a passage of wet color. When the wet paper sheen is beginning to dull, sparingly sprinkle common table salt or kosher salt on the passage. This technique will work within a limited window of time; if paper is too wet (very shiny) the salt will melt. If paper is too dry, the salt will not have enough moisture to draw away pigment to make texture. After the passage is completely dry, brush off the salt.

Scraping Light and Dark: Using a scraping tool (such as your fingernail, the chisel end of your brush, a nail, etc.) to scrape your paper in a wet or damp passage of color, creating permanent marks. Damp scraping results in light marks, and wet scraping results in dark marks. This technique can be used to portray trees, rocks, telephone lines, rigging on a ship, or any other object that is appropriate for your painting.

Sketchbook: A very useful tool that will become like a painting diary; used for value sketches, color swatches, practice painting, color notes, and

sketching in the field. Always have one with you - in your purse, briefcase or glovebox.

Staining Pigment: Sinks in and stains the paper, making it difficult or impossible to remove.

Stretching Paper: A method employed to facilitate painting on lighter weights of paper (140# or lighter) by reducing the buckling and curling that happens on lighter weights while paper is wet. Paper is affixed to a rigid support by staples or tape. See more in "Getting Started."

Texture: Can be added to a painting by use of salt, sponge, scraping, the imprint of objects, water spray, or other methods. Can bring interest or variety to a passage, but can be overused. Also refers to appearance and characteristics of watercolor paper. Paper designated as "Rough" has a bumpier texture, with peaks and valleys. "Hot-Pressed" paper is very smooth (it's difficult to do a wash on this paper without backruns), while "Cold-Pressed" paper is in between the two.

Thirsty Brush: When you wish to pull color or water away from an area: rinse your brush, then dab off excess water from the brush onto a soft cloth. Then, your brush is "thirsty," and, touched to a wet area, will "wick" color or water away from an area that is wetter than the brush. Use a thirsty brush to remove excess color, when you want a paler hue, or when an area is flooded with too much water.

Value: Used to describe relative darkness or lightness. Does not refer to hue, but to SHADE of hue. A good way to visualize value is to make a photocopy of your painting. The copy translates the colors into VALUE. Visualize a bar shaded from dark to light, with the dark end numbered "one" and the light end numbered "ten". A painting in the range of one to three would be in dark tones, and could be considered a "low key" painting; a "high key" painting is one painted in light tones: for example, in tones from six to ten on the value scale. I prefer to include a full range of values in most of my paintings, because I believe a full-range painting has more power and impact than a narrow-range painting.

Value Sketch: Quick indications, without much detail, that map your light and dark areas and the format of your painting (vertical, horizontal, round,

etc.) This step is very important and must be done for almost every painting you do. Why? Because, since (for these lessons at least) you are painting in the traditional way and saving your light areas, you must PLAN where the darks and lights will be BEFORE you begin painting. Light areas can, depending on the colors used, be reclaimed from painted paper. However, if a staining color (such as Alizarin Crimson or Thalo Green) is used, it's almost impossible to scrub out completely. Therefore, it's wise to have a plan before painting.

GETTING STARTED

WORK SPACE

When I began painting I worked at the kitchen table, spreading out my supplies when I painted and keeping them stored in a box between painting sessions. This will probably work for you also, but it's easier to find time to paint if you don't have to clear the tools away between sessions. A table permanently set up somewhere in your house will make it easier to snatch the odd half-hour to sit down and paint. Good lighting is essential. Natural light from a window facing north gives the most even and consistent light; use an elbow lamp clamped to the table with a 75-100 watt light bulb for painting at night.

STRETCHING PAPER

The day before, or at least four hours before you plan to paint, stretch your 140# paper as described below. Four hours is the estimated drying time; if desired, you can stretch the paper and dry it with a blow dryer immediately. I usually stretch four pieces at once, so I have enough to do four paintings. You'll need to have four boards and one 22" x 30" piece of watercolor paper, cut in four pieces.

Materials Needed

- A piece of 3/8" plywood, clear on one side, about 12" x 16". Tape the edges of the board with duct tape to avoid splinters. (NOTE: If you plan to use the back of your paper at some future time, it's best to seal your board beforehand with varnish and let it dry thoroughly. Otherwise, the imprint of the wood grain may show up on the back.)

- Watercolor paper, about 11" x 15" (I use d'Arches Cold Pressed 140# paper for stretching)

- 1/4" heavy duty staples and heavy duty staple gun

- Basin large enough to accommodate paper (I use the bathtub) Basin should be clean, free of soap residue.

Method

1. Soak the paper in tepid or cold water for about ten minutes.

2. Remove the paper and lay it on the board. Do NOT actually stretch the paper - this will cause it to pull away from the staples as it dries.

3. Insert staples about two inches apart. The paper will begin to buckle, but don't be concerned. It will shrink, dry taut and be ready for painting when dry. Keep the board flat while the paper is drying.

CAUTION: If a hair or bit of fluff adheres to the paper while your stretching, DO NOT try to remove it while the paper is wet. A scar may form in the tender, wet paper. Wait until it's thoroughly dry, then the hair or fluff can be easily removed by blowing or brushing it off.

ARRANGING COLORS ON YOUR PALETTE

Presently, I use a Woods palette; it's the best choice for me from what's currently available. I'm in the process of designing my own palette that will better fit my needs.

Arranging colors in your palette is a matter of personal preference; after you've painted for a while, you will determine what works best for you. I arrange my palette with cool colors (blues, greens, grays) along one end, and warm colors (reds, yellows, oranges) along the opposite end. Earth colors like Burnt Sienna or Burnt Umber are arranged between, along with temporary colors. Since I paint using the traditional transparent method, there is no white on my palette. Using the transparent method means that I "save" (or reclaim by scrubbing) the white paper, allowing the saved areas to be the lights and whites in the painting. This is the method I'll be teaching you. It's certainly permissible to use white in watercolor, but it's good to learn the traditional way first. (It's like learning to drive a standard transmission before you drive an automatic.) Also, you can achieve luminous transparency with the natural white of the paper glowing through transparent washes that can't be achieved with a layer of opaque white paint.

Decide how you want to set up your palette and squeeze in your colors. I usually squeeze a full tube into the well; the color dries and is easily transportable. Some

artists prefer to paint with fresh color each time, and put in only enough for immediate use.

Color List

Davinci

4.19	Ultramarine Blue	Indigo — 5.09
8.59	Rose Madder Genuine	Cobalt Blue — 8.59
5.09	Alizarin Crimson	Burnt Sienna — 3.19
5.09	Thalo Green	Naples Yellow — —
—	Aureolin Yellow	Indian Yellow — —

Color Descriptions

Ultramarine Blue: Semi-transparent, semi-staining warm blue, with a value range of 2-10. Makes gray with a value range of 1-10 when mixed with Burnt Sienna.

Rose Madder Genuine: Non-staining transparent red with a value range of 5-10. When mixed with Naples Yellow, makes a luscious peach hue. Makes a soft gray when mixed with Aureolin Yellow and Cobalt Blue.

Alizarin Crimson: Staining semi-transparent red with a value range of 2-10. Can be used with Ultramarine Blue or Thalo Green for a rich dark hue.

Thalo Green: Staining transparent green with value range of 2-10. Seldom used alone, but makes a wonderful rich dark green when mixed with either Alizarin Crimson or Burnt Sienna.

Aureolin Yellow: Non-staining transparent yellow with a value range of 7-10. Its transparent quality allows for a dark green when mixed with Indigo. (Most yellows are so opaque that they lighten darker hues when mixed with them.)

Indigo: Staining semi-transparent blue-gray with a value range of 1-10.

Cobalt Blue: Non-staining transparent blue with a value range of 6-10.

Burnt Sienna: Semi-staining, semi-transparent earth color, a reddish brown, with a value range of 4-10.

Naples Yellow: The lightest, most opaque (non-transparent) color on the list, with a value range of 7-10.

Indian Yellow: A bright orange-yellow, semi-staining and semi-opaque, with a value range of 6-10.

Listed below are some other materials you'll need to collect before you begin painting. Keep these materials at hand when you begin each painting session.

Basic Kit for Watercolor

- toothbrush
- table salt
- 2 water containers
- kneaded eraser
- sketchbook, approx. 11" x 17"
- white palette
- single edge razor blade

- masking tape
- paper towels
- spray bottle
- blow dryer
- sponge
- cloth diaper
- #2.5 pencil

- scraping tools (nail, toothpick, bobby pin, etc.)
- Art Masking Fluid (I use Winsor Newton)
- maskoid remover (looks like an eraser)
- Black watercolor marker pen (used in the Iris painting)
- 11" x 15" stretched 140# d'Arches Cold-Pressed paper, or unstretched 300# d'Arches Cold-Pressed paper, for paintings
- a less expensive pad of watercolor paper, about 11 x 14, for charts

Brush List

Sable brushes are wonderful - but expensive. My brush collection includes many synthetics. You'll need the following:

- one inch flat watercolor brush, with chisel end

- #6 or #8 rigger or liner

- #8 or #10 round watercolor brush

"Intuition in art is actually the result of prolonged tuition."

- Ben Shahn

CHAPTER TWO

THE BASICS

INTRODUCTION
TO
BASIC TECHNIQUES

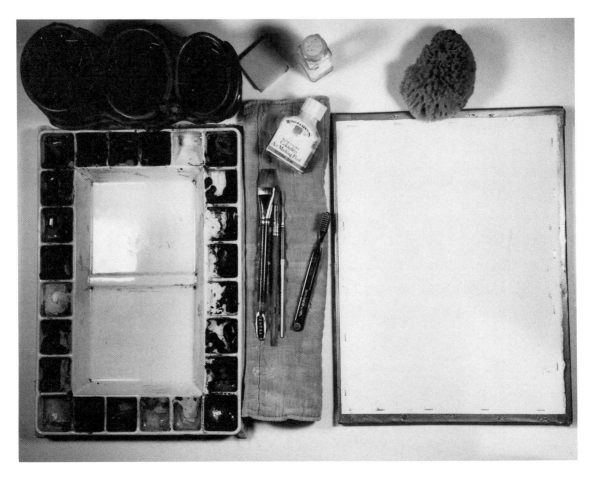

Figure 1

Prepare your painting area by placing all of your materials to your left or right, depending on which hand is dominant.

I usually place my palette to the far left (I'm left-handed), with the water containers at the head of the palette. My folded diaper lies next to the palette, with the brushes laid on top of the diaper.

The diaper is useful for "wicking" excess water from the brush, to avoid flooding an area with too much water or color. You'll find that you learn to do this automatically, by lightly touching the loaded brush tip to the diaper to take the excess moisture out. Next to the diaper, squarely in front of me, is my paper. Other materials are arranged to the left or above the paper. (Figure 1.)

You can use your inexpensive watercolor pad for the charts that follow. These charts will acquaint you with some of the characteristics of your materials.

PAINT CONSISTENCY

If you've read the first chapter, you have your palette set up with colors already in place. Your colors are probably fresh from the tube, so you must use care when dipping into the well of color - don't get too large a portion on your brush. Using your 1" flat, dab your brushload of paint into the center of the palette, the mixing tray. Add two brushloads of water to the pile of color, mixing well with your brush. Your puddle of color should be about the consistency of heavy cream. Now, begin to apply color to your paper; paint a bar of about 1" by 4". Add more water to lighten the value of the color, two or three more brushloads. You'll notice that the puddle is now much thinner, and the paint leaves the brush more easily. Paint another bar near, but not touching, the first bar. Compare them; one is lighter in value, the other more intense or darker. Instead of adding white paint to lighten a color, you've added water. Repeat the above steps with another color.

SCRAPING LIGHT AND DARK

Scraping can be used to denote background forest, power lines, rocks, and a variety of other elements. You can even sign your painting by scraping into wet color. Some of the tools that you can use are: a toothpick, paperclip, or the chisel end of your brush. The flat edge of a stiff plastic card can be used for scraping rock shapes. Scraping the paper while the color is very wet results in dark marks; the wet color rushes into the scar formed by scraping. Scraping done on dryer (but still damp) paper will result in light marks; the color stays pushed away from the scar, so the light paper shows through. REMEMBER that any scraping results in PERMANENT marks in your paper. Paint another band or two of color and scrape with some of your tools. See Figure 2.

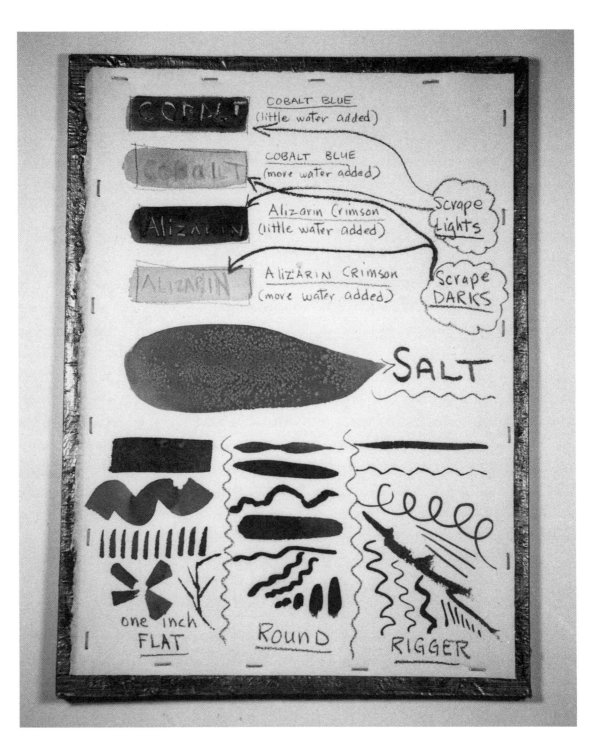

Figure 2

SALT TEXTURE

Mix up some color to a consistency of light cream. Paint an area of color about three inches in diameter; when the wet paper sheen is beginning to dull, sparingly sprinkle salt on the area. Slowly the salt will begin to draw up the water and pigment, leaving dots of texture. This technique will work within a limited window of time: if the paper is too wet, very shiny, the salt will melt without leaving a texture. If it's too dry, the salt will not have enough moisture to draw away pigment. NOTE: You can scrape both before and after you use salt. See Figure 2.

USING THE BRUSHES

Each one of your brushes will make a variety of shapes. Make as many shapes as you can. Variation in pressure, angle to the paper, amount of paint, speed of stroke and wrist movement will result in different effects. See Figure 2.

TOOTHBRUSH SPATTER

This effect can be used to portray sand, foliage, or texture on rocks or a variety of other objects. Wet one half of a practice area. Scrub your toothbrush into the wet color puddle on your palette and run your thumb across the bristles while sweeping your hand above both the dry and wet sides of the practice area. The color diffuses when it hits the wet side, and keeps its shape on the dry side. Do this with several color puddles, spattering one color over another. See Figure 3.

NEGATIVE PAINTING/ WET IN WET WASH

Negative painting describes the action of making a shape appear by applying color around the shape, right up to the edge of it. The following steps detail the process (See Fig. 3):

1. With your pencil, outline your name on a practice sheet, making fat balloon letters that are separated from one another.

2. Make two separate puddles of color, about two teaspoons each, medium thickness (the consistency of cream) in your palette mixing area.

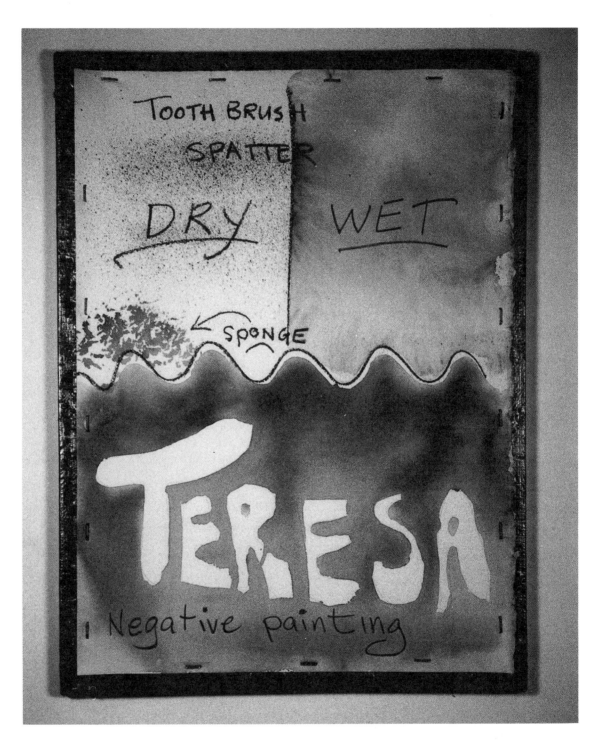

Figure 3

3. Using lots of clean water, wet the area around the letters coming right up to the pencil lines. Don't get any water on the letters themselves.

4. Tilt the paper to let excess water drain off onto your cotton rag or diaper.

5. Immediately begin applying paint, one color at a time, to the wet area. See how the colors spread and mix together? This is a wet-in-wet wash.

6. Pick up the paper and tip it to facilitate the mixing. The colors should run everywhere except on the letters, because the letters are dry. Tip the paper until the color comes right up to the edge of the letters, so each one will be clearly defined. The area where your name appears is actually bare paper. This is the process of negative painting, so called because you paint the negative space around the positive object. If you like, when the color reaches the proper stage of dampness, add salt to practice that technique again.

SPONGE TEXTURE

Different sponges make different textural marks. Try both natural and synthetic, dipped into a wet puddle of color, then LIGHTLY dabbed on paper. You'll use a larger puddle than you think, because the sponge soaks up a lot of the color. Sponge texture can be used to portray foliage and texture on other objects. (Fig. 3)

BLENDING OFF/GRADED WASH

This technique is a process of gradually changing tone in a defined area from dark to light; it's essential to learn if you want softly shaded effects in your paintings. The following exercise will give you practice in controlling color in a small area (Fig. 4).

1. With your pencil make ten separate circles by tracing around a bottle cap or quarter.

2. Take your round brush and mix some pure color with water to the consistency of cream.

3. Rinse your brush, dab off any excess water on the diaper, and dip it into the mixed color.

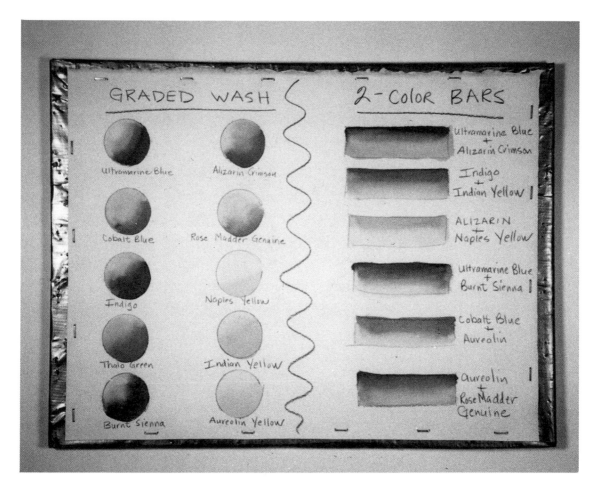

Figure 4

4. Apply the color along one side of a circle, then immediately rinse your brush, touch it to the diaper to wick away excess water, and blend the color by just touching the edge of the wash and pulling color across the circle. The goal is to have the color darker on one side gradually lightening to the other side, with a smooth transition and no "hard" lines. Blooms, or backruns, appear as hard lines or edges inside the graded wash. They result when the added water from the second stroke runs back into the initial wash. The initial stroke is dryer than the fresh water, hence the hard line when the water pushes the color back. To avoid this, tip your paper slightly toward your brush as you pull color across, using gravity to make the excess water settle away from the color strip. Another cause of hard lines is too long a delay before the second stroke. The color has a chance to set up in its original place.

5. If there is still a puddle inside the circle after you pull color across, scoop it off with a "thirsty brush." Rinse the brush, dab it on the diaper several times so that the brush is just damp. Touch the puddle with the damp brush and it will "wick" the puddle away.

6. Make a graded wash circle for each color on the list.

COLOR MIXING

1. Draw six or seven bars on your paper, about 1" x 4". (Fig. 4)

2. Using your existing puddles of color from the last exercise, mix a little of two different colors together.

3. Paint an edge horizontally across the length of one of the bars, then blend across to the other edge of the bar with clean water. This will be a bit harder than the circles, as you have a longer line of color to blend smoothly.

4. Experiment with the puddles to see what colors result, each time painting a color bar and blending across. Expect to get some hard lines and blooms in your wash - this is a difficult technique to master. Be patient with yourself.

"You may be disappointed if you fail, but you are doomed if you don't try."

- Beverly Sills

CHAPTER THREE

FIRST PAINTINGS, STEP-BY-STEP

MONOCHROMATIC PAINTINGS; VALUE COMPARISON

BEACH BALL WITH SHADOW

Color Plate 1

Now that you've had a taste of some techniques, let's paint a monochromatic (one color) painting. You'll be painting this piece twice; first using Ultramarine Blue (full value range) and then Naples Yellow (high key painting with limited value range). Painting it twice will give you practice and enable you to clearly see the term "value" illustrated.

Materials Needed

- round brush

- flat brush

- rigger brush

- sketchbook

- Ultramarine Blue

- 11 x 15 watercolor paper, divided into two areas by tape

- No. 2.5 pencil

- value sketch

- Naples Yellow, for second painting

1. Draw a value sketch (Fig. 5) in your sketchbook. This is the plan for your painting.

2. Complete the line drawing (Fig. 5) on your watercolor paper, making the ball about 2" in diameter.

3. Mix Ultra. Blue with water to a light midtone; on a value scale it would be about range 7, the consistency of skim milk. You'll need a couple of teaspoons.

4. Using your 1" flat brush, paint clean water around the ball, leaving only the ball dry.

5. Tip your paper to drain off excess water. Lay in color, tipping the paper so that the wash spreads evenly, right up to the edge of the dry ball. (Fig. 6) Lay it flat to dry.

After the paint has set in the paper and lost its shine, you can speed drying with the blow dryer on cool setting.

6. To paint the shadowed side of the ball, you need to add paint to the existing puddle making it darker. Mix to a consistency of light cream, value range 5. Using your round brush, paint a strip of color inside the lower right edge of the ball and blend up the side of the ball, toward the light side (Fig. 7). Try to blend out the color until it fades completely, giving the ball a white or

Notes
This is <u>your</u> book; personalize it by making your own notes in these boxes.

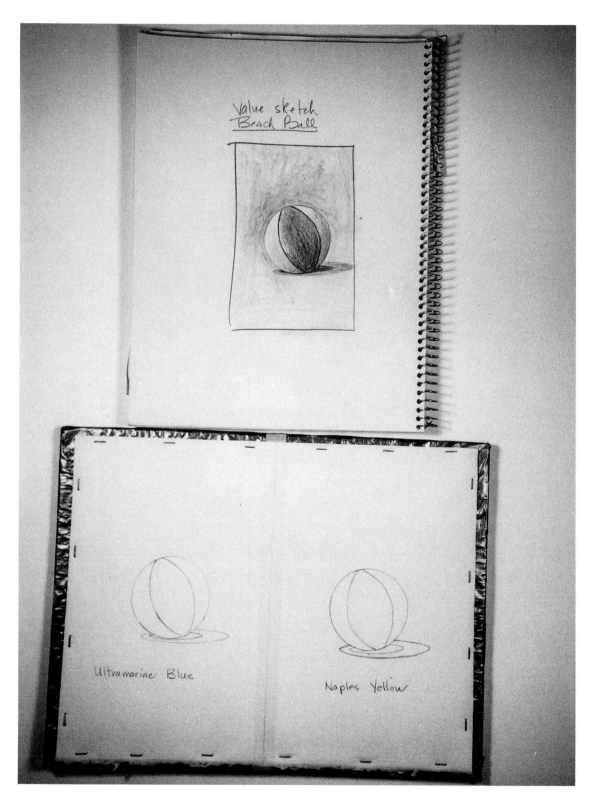

Figure 5

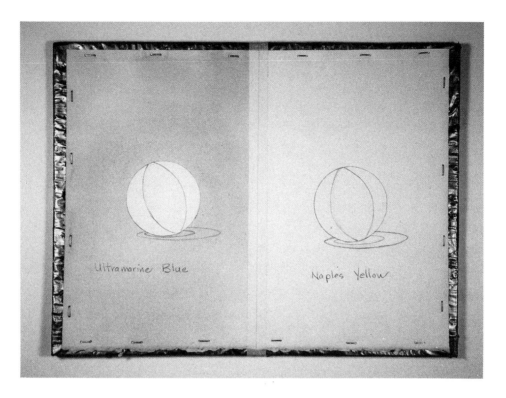

Figure 6

very light tone on the upper left. This is where the light is striking the ball. Now, dry the paper.

7. Add more color to your puddle for a value of about 4, and paint the wide stripe on the ball (Fig. 8). Dry.

8. With the same puddle, paint the darkest area of shadow around the bottom of the ball (Fig. 9). Let dry.

9. Add even more color to the puddle, to a dark range of 2 (this will be quite thick), and use your rigger brush to paint the darker pin stripes along the edge of the wide stripe (Fig. 9).

Notes

Use your kneaded eraser if necessary; other erasers scar the paper.

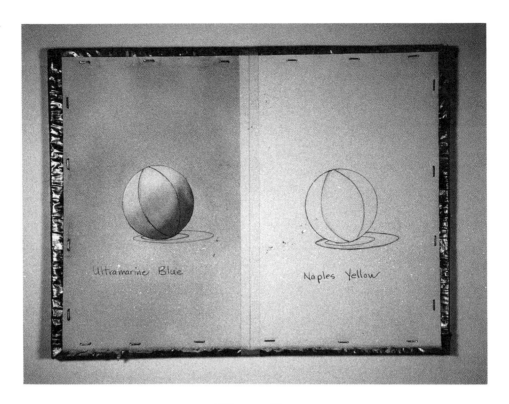

Figure 7

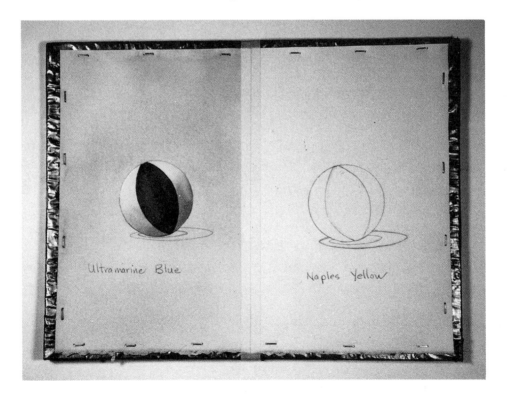

Figure 8

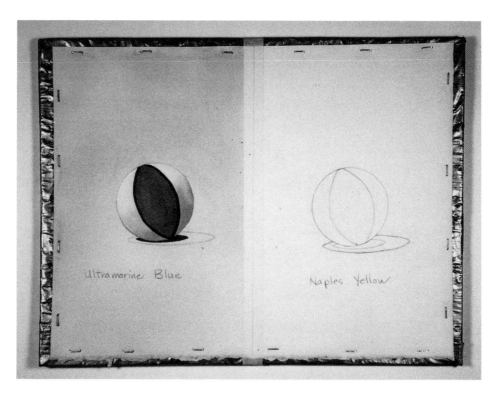

Figure 9

10. Add some water to the puddle to lighten it to a value of 5 or 6 and paint the secondary shadow (Fig. 10). Let dry.

11. Congratulations! You've finished your first watercolor painting. You have a full range of value, from very dark to very light. Sign the painting with your rigger brush.

12. Start over and paint the ball again, using Naples Yellow. You'll notice that Naples Yellow is not capable of going below a range of 6 to get to the darkest darks, so you're really painting from

Notes

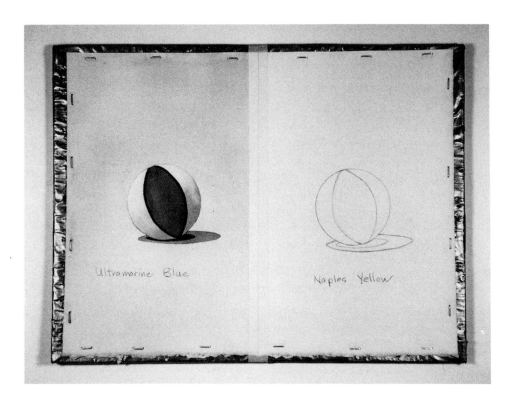

Figure 10

range 6 to 10, a "high key" painting. Naples Yellow is the most opaque color on your palette due to the amount of white in it.

13. When you're finished, compare the two paintings (Fig. 11, and Color Plate 1). View the paintings from 20 feet away. Which one has more impact? Make a photocopy of the paintings, translating color into black and white, to compare the value. The yellow painting almost disappears because of the lack of contrast.

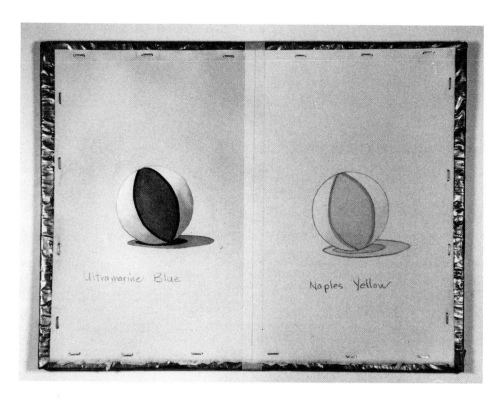

Figure 11

TWO COLOR PAINTING

SNOW AND FOREST
Color Plate 2

Now you'll take your experience a step further, adding another color to your repertoire. With Burnt Sienna and Ultramarine Blue, you'll paint the landscape in Color Plate 2, using more techniques from Chapter Two.

Materials Needed

- value sketch
- Ultramarine Blue
- Burnt Sienna
- flat brush
- round brush
- rigger brush
- salt
- diaper
- 11"x 15" stretched paper

1. Do your value sketch and line drawing (Fig.12).

2. Make puddles of the following mixtures:

> Ultra. Blue, value 7
> Burnt Sienna, value 4
> B. Sienna + Ultra. Blue, value 4

3. Using your flat brush, wet the top half of your paper from the snow line up. Use lots of water. When you're ready to paint, tip your paper to drain off excess water and begin.

4. Paint the light Ultra. Blue into the sky portion (Fig. 13). Tip the paper to spread the color around the sky. Immediately, add a couple of brushloads of Burnt Sienna in vertical strokes starting at the snow line. Add some of the dark mixture in several places right over the Burnt Sienna. (Be careful not to cover ALL the Burnt Sienna - you want color variety in your background forest.) Tip your paper around to blend the colors a bit.

5. Begin scraping the paper with the chisel end of your flat brush or other scraping tool to make tree and twig shapes. These scrapings will be dark since the color is very wet. You can pull some wet color down into the snow area for the bases of trees (Fig. 14).

Notes

35

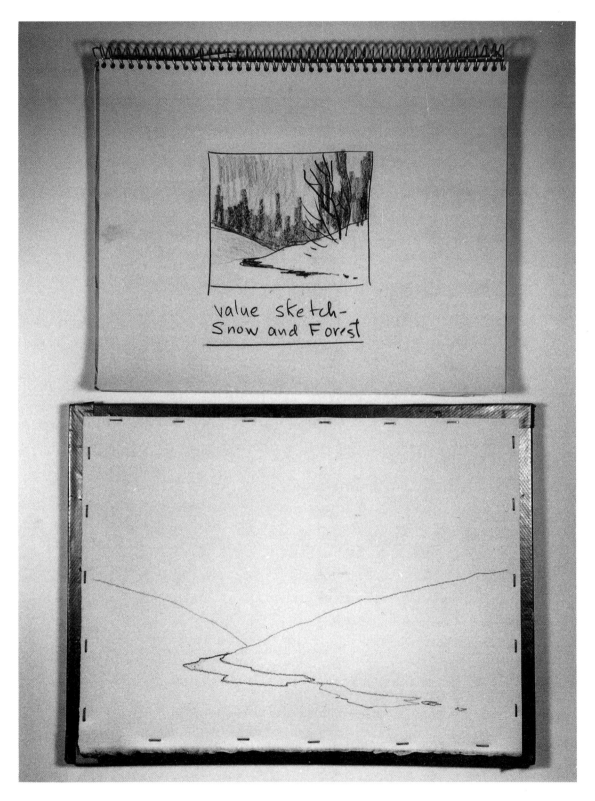

Figure 12

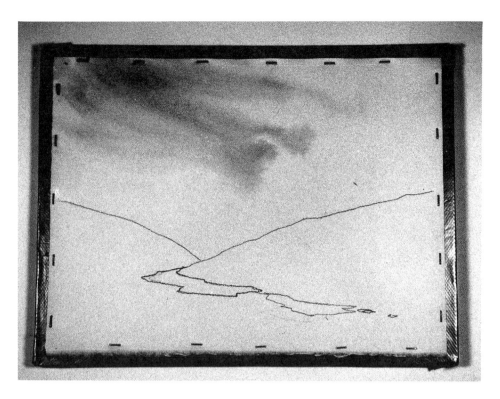

Figure 13

6. When the paper begins to lose its shine, sprinkle salt into the forest area. The salt will begin to soak up pigment to make a textured area (This will take three to five minutes to work.)

7. When the paper has dulled somewhat, scrape some light trees into the forest area for variety (Fig. 14). Let dry.

8. You're ready to paint contour shadows on the snowbanks. Sunlight is coming from the upper left, so the bank on the left curves away from the light into shade. Using the sky puddle and your round brush, lay a strip of color along

Notes

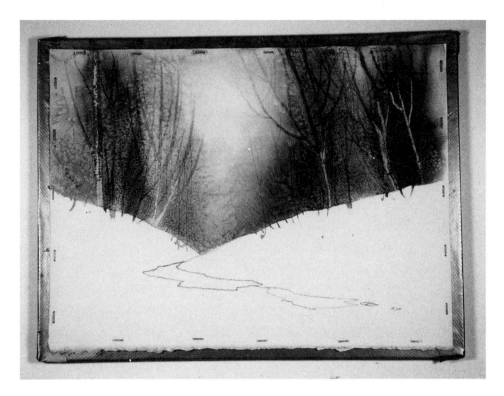

Figure 14

Notes

the base of the far bank. Immediately, rinse your brush and blend in a graded wash up the bank, tipping the paper slightly from the bottom to help the wash blend (Fig. 15). Let dry.

9. The bank on the right is curved toward the light, so the only shadows there will be cast from the trees and twigs we'll paint later.

10. Thirsty Brush stream: Using the flat brush and reflecting the colors in the background forest, lay in either Burnt Sienna or the dark mixture (or both) in a stream pattern (Fig. 16). Be sure to

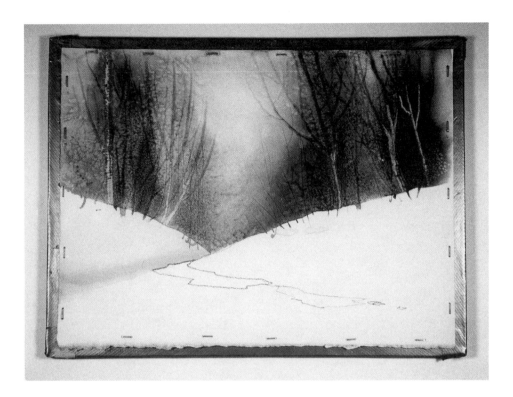

Figure 15

hold the brush so that the bristles are parallel to the bottom edge of the page to portray the flat area of water.

11. Study Figure 16. Rinse your brush and gently squeeze out the water with a wad of paper towel held in your other hand. Touch the water area with your "thirsty" brush and make vertical marks in the water area. Each time you touch the water area, gently squeeze the color out of the brush with paper towel. This technique will add to the illusion of a stream of water by applying the principle of "verticals and

Notes

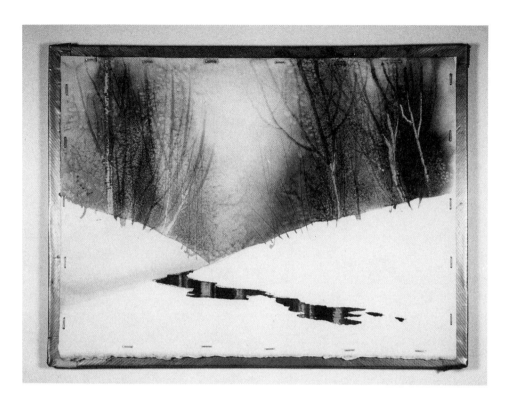

Figure 16

Notes

horizontals" in portraying still water. The verticals are reflected shapes from the forest or areas of glare on the water.

12. Study Figure 17. Practice making branch and twig shapes in your sketchbook with the rigger brush and the two forest puddles. Do a page or two of tree and twig shapes before painting them on your painting. Then go ahead and add some to the painting. Let dry.

13. Using the rigger and the Ultra. Blue puddle, paint cast shadows from the trees and twigs in the snowbanks (Fig. 18).

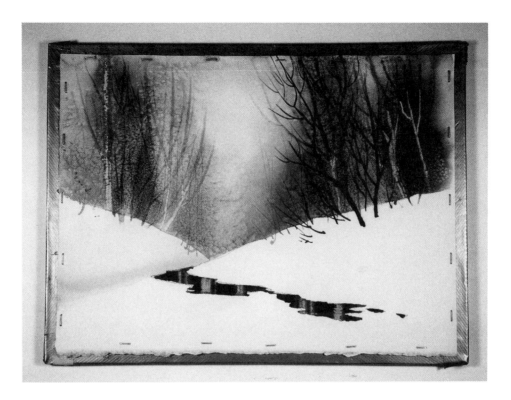

Figure 17

14. Sparingly scatter some toothbrush spatter, using all three colors, across the snow bank to soften the effect and remove the stark whiteness (Fig. 18).

15. Congratulations! It's time to sign your <u>Snow and Forest</u> painting and view your work from a distance. Set the painting up and step back to study your work. Above all, don't be too fussy or self-critical at this stage of your development. Remember, you are learning a new skill, and every skill takes considerable practice to develop. If you are unhappy with the results,

Notes

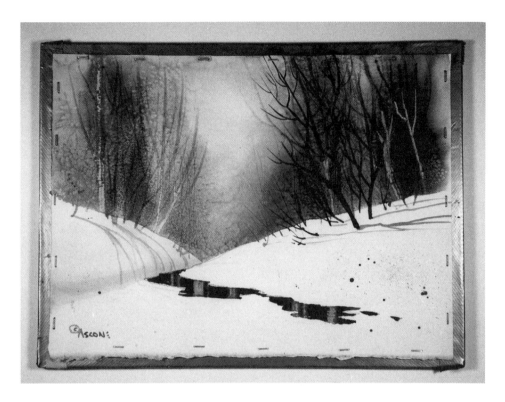

Figure 18

Notes

paint the piece again. The second effort will almost certainly be more pleasing than the first, because already you've learned a great deal.

*"Use the ability you already have, and use it,
and use it, and make it develop itself."*

- <u>The Art Spirit</u> by Robert Henri

CHAPTER FOUR

INTERMEDIATE PAINTINGS,
STEP-BY-STEP

The next section will offer a series of five prepared compositions that will enable you to practice applying some of the principles you have learned in the earlier sections, and will introduce more techniques and materials. Working with prepared compositions will allow you to concentrate on the techniques only.

The subject of the painting is not the main concern here. This is the time to develop your technical skills so that later you can concentrate on personal interpretation and expression. Just as you cannot compose a concerto until you have mastered the scale and the subtleties of sixteenth notes and chords, it is difficult to paint a dynamic and expressive watercolor without learning the techniques to expand your painting "vocabulary." So, take a deep breath and let's move on to the next section (Be sure to read the entire section before beginning).

Note: Keep all the materials listed in the basic kit on hand. You'll be using an 11" x 15" piece of d'Arches paper for each painting.

WINTER BIRCH

Color Plate 3

Artists sometimes get caught in the trap of using only cold colors when painting snow scenes - it's natural for us to think "cold blues and greens" when we think of freezing ice and snow. But in a winter scene, warm colors are important to achieve a good balance of temperature in the painting. Blues and greens can dominate, but touches of warmth are necessary to create interest and avoid monotony.

Actually, there is a surprising amount of warm color that occurs in winter. Warm sunsets in peach and pink can be reflected in the snow and water. Twigs and brush sometimes have a reddish hue, yellow and brown can be used to portray dried grass. The bark of the birch tree also has lots of warm color that can bring warmth to your painting, as well as an interesting dark and light pattern.

I began painting birch trees soon after I started painting in watercolor. Paper birch and clump birch are common in the Anchorage area, both in and out of the city. In fact, I needed to look no further than my own back yard. Talk about convenient subject matter!

I use the dark branches of the birch to add "calligraphic" strokes to the painting. These lacy, spidery strokes add variation in line and a graceful delicacy that offset the larger, chunkier shapes in the painting. Well-placed branches and twigs can direct the eye through the painting and back to the center of interest. This is done both through line direction, and through value contrast of dark against light.

Colors:
- Thalo or Winsor Green
- Ultramarine Blue
- Burnt Sienna
- Alizarin Crimson
- Indian Yellow

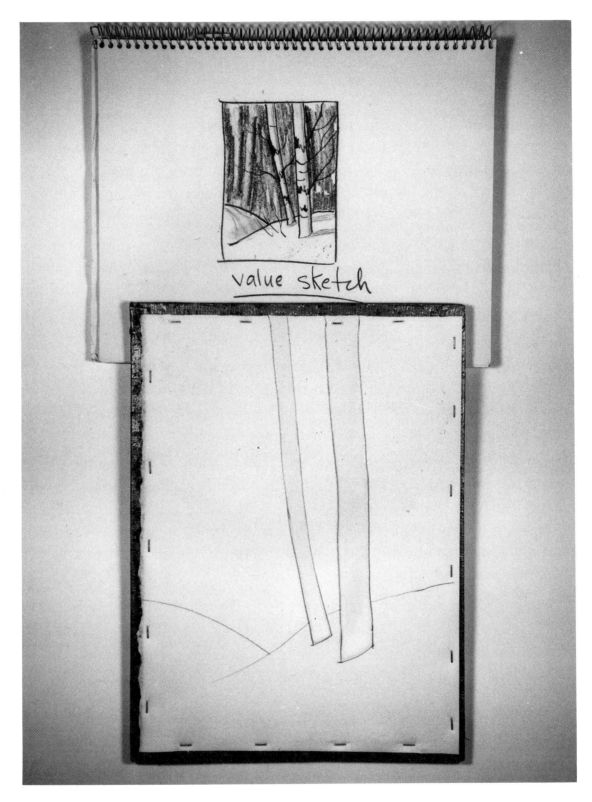

value sketch

Figure 19

1. Transfer the value sketch in Fig. 19 into your sketchbook. Note where the darks, lights and midtones will be.

2. Place the line drawing on your watercolor paper.

3. Using the round brush, protect the two foreground tree trunks from the background wash by masking them with maskoid (Review the procedure in Chapter One Definitions). Let the masking fluid dry - it may take 15-20 minutes. Don't use the blow dryer, since this might cause the maskoid to bond with the paper, making it difficult to remove. Use the maskoid generously to facilitate easy removal later.

4. This is a chance to practice the background foliage technique you learned in the two-color painting, Snow and Forest. Mix the following puddles of paint, all to the consistency of heavy cream:

 • Ultra. Blue + Burnt Sienna

 • Thalo Green + Alizarin Crimson

 • Alizarin Crimson + Ultra. Blue

 • Burnt Sienna alone

5. Using your flat brush, wet the top portion of the paper from the snowline. Use lots of water. When you're ready to paint, tip your paper to drain off excess water on the diaper.

Notes

Figure 20

Notes

6. Immediately add each of the mixtures in vertical stripes, from the snow line to the top of the paper. Tip the paper from side to side to blend the stripes of color.

7. Begin scraping the paper with the chisel end of your flat brush to make tree and twig shapes (Fig. 20). These scrapings will be dark since the color is very wet. You can pull wet color down into the snow area for the bases of trees.

8. When the paper begins to lose its shine, sparingly sprinkle salt into the forest area for texture. Dry the painting and

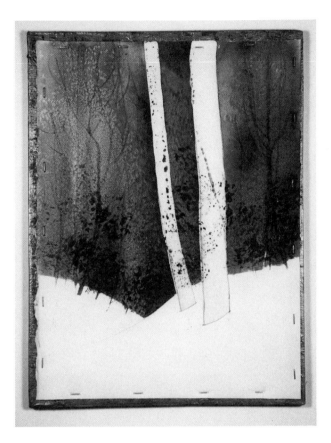

Figure 21

brush off the salt.

9. Use the sponge to add texture variety to the foliage area (Fig. 21). Mix water with Alizarin Crimson for a dark red tone. Dab your sponge into the color and lightly touch it to the paper. Dry the painting.

10. Lifting color: Some indistinct, suggested tree shapes can be added to the background that will "echo" the birch trees, Fig. 22. Take two pieces of masking tape. (Before placing the tape on my paper, I usually stick the tape to a slick surface, such as a countertop, to

Notes

If Alizarin seems too bright, tone it down with just a touch of Thalo green.

51

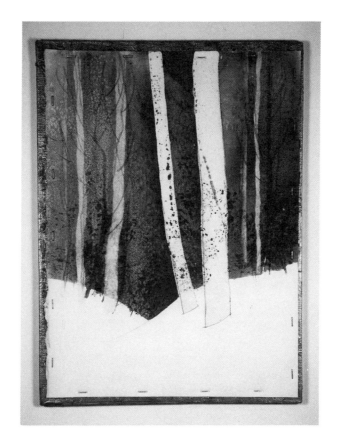

Figure 22

Notes

To avoid ruler-straight trees, tear the tape (lengthwise) in half and lay the torn edges facing each other; then scrub between them.

remove some of the stickiness. This reduces the possibility of taking up paper when you remove the tape.) Lay the tape strips parallel to each other, leaving about 1/2" of space between them (the space between will be your light tree). Scrub gently between the tape strips with water and your toothbrush to lift color, blotting carefully with paper towel. Remove the tape. Dry the paper and repeat the above steps for each light tree shape. (Avoid the picket fence effect by varying the sizes and angles.)

11. You're ready to paint the contour

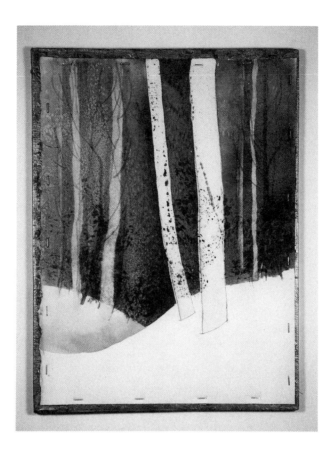

Figure 23

shadows on the distant snowbank (Fig. 23). Sunlight is coming from the upper left; the distant bank curves away from the light into shade. Using your round brush and the Ultra. Blue, value 5, lay a brushload of color along the base of the bank. Blend in a graded wash up the bank, tipping the paper slightly from the bottom to help the wash blend. Dry the painting.

12. Cast shadows, Fig. 24: Cast shadows are important if your painting has a definite source of light, because they give the viewer another "clue" that bright sunlight is present in the scene,

Notes

53

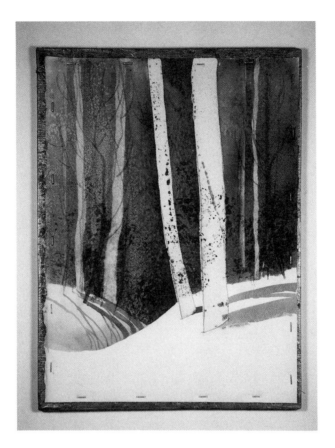

Figure 24

Notes

and also give you another opportunity to describe the shape of the terrain. The profile of the terrain tells the shape also.

Using the same Ultra. Blue puddle of shadow color and your round brush, paint a cast shadow from some of the background trees. Make sure the shadows go in the same general direction. Then paint cast shadows from the two main trees. Be sure to follow the terrain - the curves and hollows - of the snowbank. Dry.

13. Birch trees: It's time to remove the

54

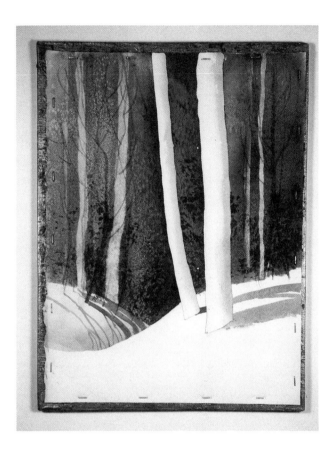

Figure 25

maskoid. Raise one end with your eraser or maskoid remover, then pull the maskoid off. Your trees are ready to paint.

14. Paint the shaded side of each tree with Ultra. Blue (Fig. 25) blending toward the middle of the tree. Use the rigger brush. Paint only about 1/4 the width of the tree, otherwise you'll end up with the entire tree shaded. Dry.

15. Paint the sunstruck side of the trees using the round brush, with pale Indian Yellow, value 8. (Use lots of water, just a little pigment - yellow trees is not the

Notes

Notes

objective, "sun-washed" is.) Blend the color over the entire tree; this will alter the tree shadow to make it a bit different than the snow shadows. Dry.

16. Mix the following two puddles, heavy cream thickness (The key to the success of this technique is thickness of paint - you don't want it to spread too much):

• Burnt Sienna

• Burnt Sienna + Ultramarine Blue (dark gray)

17. Now, work on one tree at a time. Using clean water, wet the most distant tree. Don't puddle the water - scoop off any excess with a thirsty brush. Using the rigger, paint dabs of Burnt Sienna here and there on the trunk. Paint dabs of the dark gray mixture (See Fig. 26). These two colors will begin to spread; use the chisel end of your flat brush and scrape rings into the trunk, like those that appear on birch trees. Using the dark gray mixture, paint branches off the trunk - paint should spread on the trunk to make a convincing join. Dry.

18. Work on the closest tree, using the same techniques. The only difference is that you'll be painting some branches overlapping the more distant tree (Fig. 27). Dry.

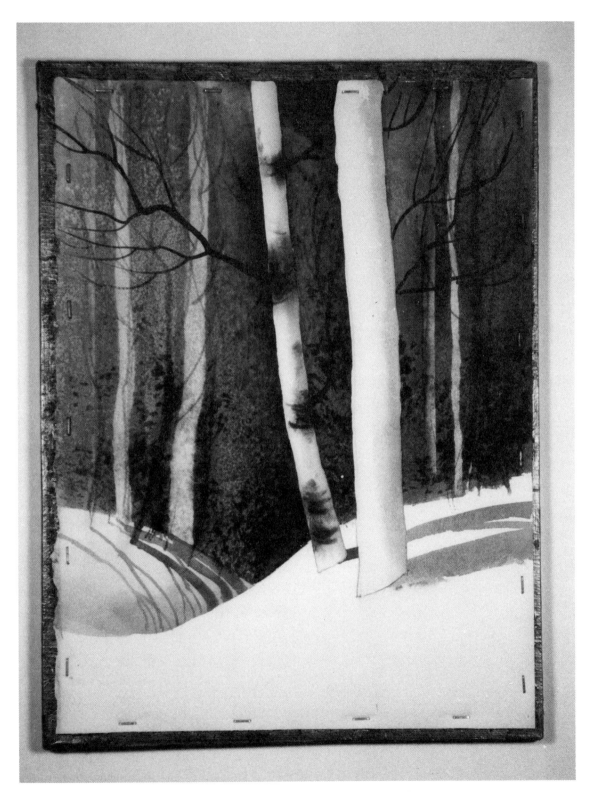

Figure 26

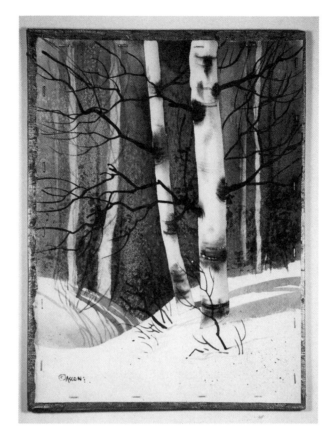

Figure 27

Notes

19. Using both mixtures, paint twigs and branches in the snow. Use Ultra. Blue to paint their cast shadows (Fig. 27).

20. Use the toothbrush to spatter some of all the colors in the snow.

21. Sign it! You're finished. View the painting from a distance to appreciate your efforts.

CLIFFSIDE: TURNAGAIN COAST

Color Plate 4

When I paint, I am attempting to be a communicator. I want the viewer to see what struck me when I saw a particular element of a landscape - the light, color, texture or mood. Rocks are one of my favorite subjects. I like the way they fit together, the solidity and angularity; I like the feeling of massive strength and endurance they symbolize. I also like the idea that the Chugach Range is growing a fraction of an inch every year, and that slopes are gradually changed by earthquakes, avalanches and our extreme weather.

Just south of Anchorage is a passage of water called Turnagain Arm. This blind inlet, surrounded on three sides by high peaks, was named by Captain James Cook two hundred years ago. This area is a painter's paradise (as is much of Alaska) because of the grandeur of the rugged landscape, and the variety of elements to portray. I love to paint the rocky cliffs and varied foliage along this winding stretch of coast. The same scene can be painted over and over again - in different seasons and under different light conditions. Think of Utrillo's famous series of haystacks and cathedrals, and you'll realize how various one object or facade can be.

Although this is a precipitous Alaskan scene, you can find similar scenes from Maine to Monterey. Hoard them in your sketchbook.

Colors:

- Indian Yellow
- Ultramarine Blue
- Indigo
- Cobalt Blue
- Burnt Sienna
- Alizarin Crimson
- Aureolin Yellow

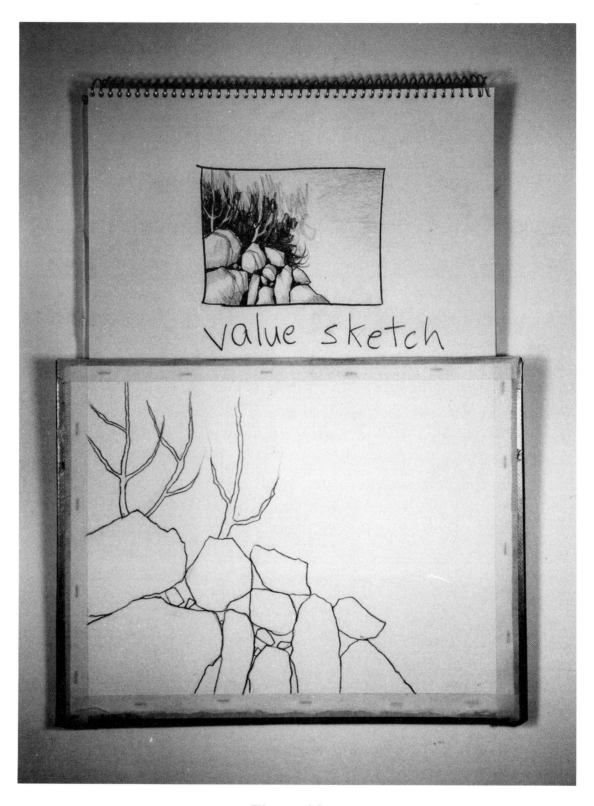

Figure 28

> Notice that I taped the edges of the paper this time, for a clean border.

Notes

1. Transfer the value sketch to your sketchbook (Fig. 28).

2. Carefully place the drawing on your paper. Observe the foliage branch and twig pattern - you'll be doing some negative painting over the first wash in this area, so the pencil lines can be a bit darker to show through. While drawing the rock shapes, pay attention to outlines, contours, sizes, and positions so there will be variety in your rockpile.

3. For a different way of signing your painting, use a wooden matchstick or other tool and sign the painting with maskoid in the rock area. Just dip it into the maskoid, sign, and discard the matchstick. Let the mask dry before continuing. When the painting is finished, remove the mask; the signature will be white against the darker value of rocks. If it stands out too much, tone down the white by going over it with a light wash of color.

4. Begin by mixing a little Cobalt Blue with water, to a value of 7, the consistency of skim milk. This will be the sky color.

5. Prepare the following mixtures for

Notes

foliage. Mix each one to a consistency of milk:

- Indigo + Aureolin Yellow
- Ultra. Blue + Indian Yellow
- Burnt Sienna + water

6. Study Color Plate 4, noticing the shapes of the sky area and foliage. You'll be painting the sky and foliage in the first wet-in-wet section. With your 1" flat brush, wet the sky and foliage areas, leaving the rocks dry. Drain off excess water.

7. Paint a couple of strokes of the Cobalt Blue into the upper right area (Fig. 29). Tip the paper to blend the edge softly. Lay in the three foliage colors in a foliage pattern (think rounded, irregular shapes), tipping the paper slightly to blend. This area will be your soft-edged layer of foliage (Fig. 30). Dry.

8. Negative painting: Study the foliage area and re-establish the branch and twig drawing if necessary. (You'll need to be able to see the pencil lines well to paint around them.) Mix the following dark midtone (4) value:

- Indigo + Aureolin

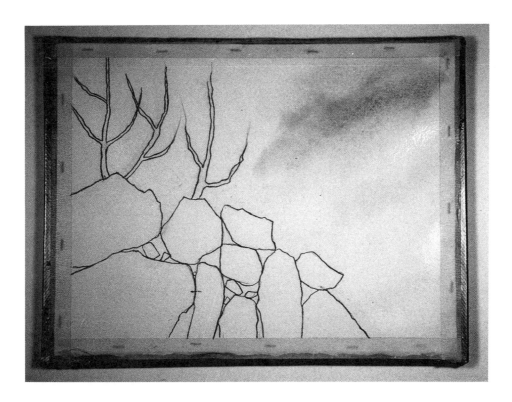

Figure 29

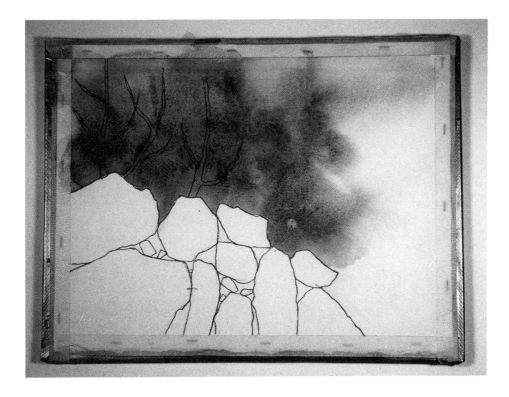

Figure 30

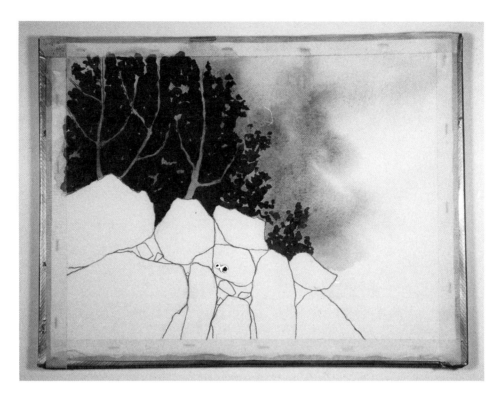

Figure 31

Notes

This mixture will be used to paint the darker value behind the branch and tree shapes to make them stand out (Fig. 31). It will also extend up into the soft-edged foliage, dabbed into a lacy, hard-edged foliage pattern. Using the rigger, paint around the branches and twigs you drew, extending the foliage. Dry. When the painting is completely dry, you can erase the pencil lines if desired.(In future paintings, you'll want to vary your darks for interest and variety. In this painting, you used one dark to avoid confusion.)

9. Initial Rock Wash: Study Figure 32.

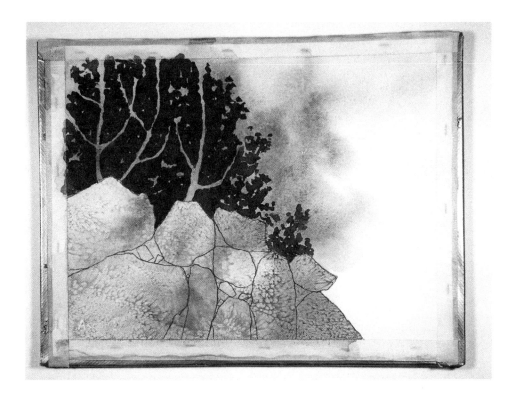

Figure 32

Mix 4 separate puddles of the following paints, each to the consistency of skim milk:

- Burnt Sienna
- Indian Yellow
- Ultramarine Blue + Alizarin Crimson
- Indigo

10. Wet the entire rock area, including the spaces between the rocks. Lay in the

Notes

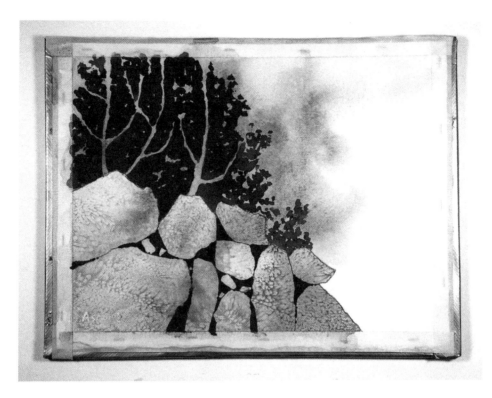

Figure 33

Notes

colors, one at a time, without regard to individual rocks (color overlap will unify the area). Tip the paper to blend colors, and when the wash is ready, use salt for texture. Dry and brush off the salt.

11. Negative Painting: If necessary, re-establish your drawing in the rock area. Mix a dark (2) value of Indigo + Burnt Sienna, the consistency of thick cream. Use this mixture to paint the spaces between the rocks (Fig. 33). Dry the painting and view it from a distance - you've made the individual rocks appear by painting between them.

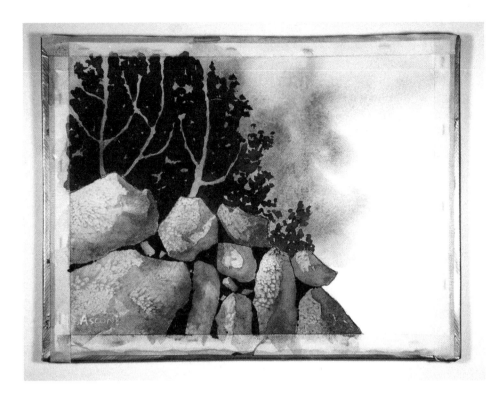

Figure 34

12. Rock Contours: You'll give the rocks substance and form in this step. Mix Cobalt Blue with water to a consistency of milk. Cobalt Blue is a transparent color, so the initial wash will show through to maintain the local color of the rocks. Study Figure 34, then paint the shaded sides of each rock. Dry.

13. Using the rigger and the dark mixture from Step 11, paint some additional twigs and branches in the foliage.

14. Cast some tree and twig shadows over the rocks, following their contours, using

Notes

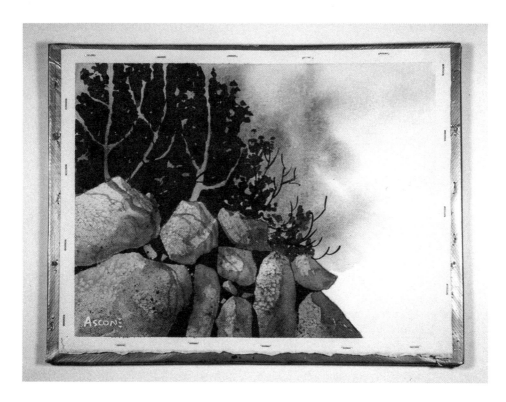

Figure 35

Notes

the blue shadow color, Figure 35. Dry.

15. Using all the colors one at a time, spatter the rocks with the toothbrush to add another kind of texture. (Shield the rest of the painting with pieces of paper towel). Dry.

16. If you used the maskoid signature method, remove the mask.

17. Great work! You've completed the painting, another step along the way to mastery of these basic techniques. Give yourself a pat on the back. And remember, as someone said, success is not a destination - but a journey.

SNOW-COVERED PEAKS

Color Plate 5

Alaskans enjoy some of the most awesome and beautiful mountain ranges in the world; Denali, the tallest mountain on the North American continent, is but one of the many massive peaks that tower over our land. On clear days, we can see its peak 250 miles to the north.

The mountains called the Chugach Range, located to the east of Anchorage, are a favorite painting subject of mine. I've always been fascinated by their ever-changing moods. As a child, I remember pausing as I walked to school, absorbed in their beauty and mystery, awed by their graceful, rhythmic curves and angles. Even now, after years of seeing the Chugach, I have to be careful driving my car - I get distracted, looking at their rugged slopes, watching the slowly changing effects of light and shadow.

When I started painting, these mountains were my first subjects; I'd contemplate which pigment would best portray the colors of the sunrise behind them, the alpenglow on their distant ridges; which technique would best portray their moods and mists. Misty, clear, snow-covered, or rocky, viewed from the north end of town or from Potter's Marsh to the south, they afford many different manifestations that a painter could spend a lifetime capturing.

Mountains remind me of undulating ocean waves frozen in mid-crash: rhythmic, with the peaks the crest of a wave. When the wind blows snow from the peaks, it evokes the feeling of ocean spray blown off the whitecaps by gale force winds.

In the birch tree painting, the scene consisted of middle ground and foreground. For Snow-Covered Peaks, you'll be portraying distant background, middle ground, and foreground to evoke a three-dimensional feeling. It'll seem as if you can walk forever back into the painting! This three-dimensional effect can be accomplished by employing:

1. Aerial perspective (whereby distant objects are more neutral, or cooler in color than closer objects, and/or of paler value than middle or foreground objects)

2. Overlapping successively closer objects

3. Portraying distant objects smaller in relation to closer objects. (We know that a mountain is taller than a tree, but the tree appears taller when it is close to us.)

You'll be trying out some new color mixtures for your brilliant sky. Naples Yellow, the most opaque color on your palette, will be mixed with Rose Madder Genuine for a lush, creamy peach hue. To simplify the composition, I've smoothed and combined the complicated mountain shapes and tiny cliffs and ridges into larger, basic shapes to portray them clearly.

Be sure to read over the entire section before beginning.

Colors:

- Rose Madder Genuine

- Cobalt Blue

- Naples Yellow

- Burnt Sienna

- Indigo

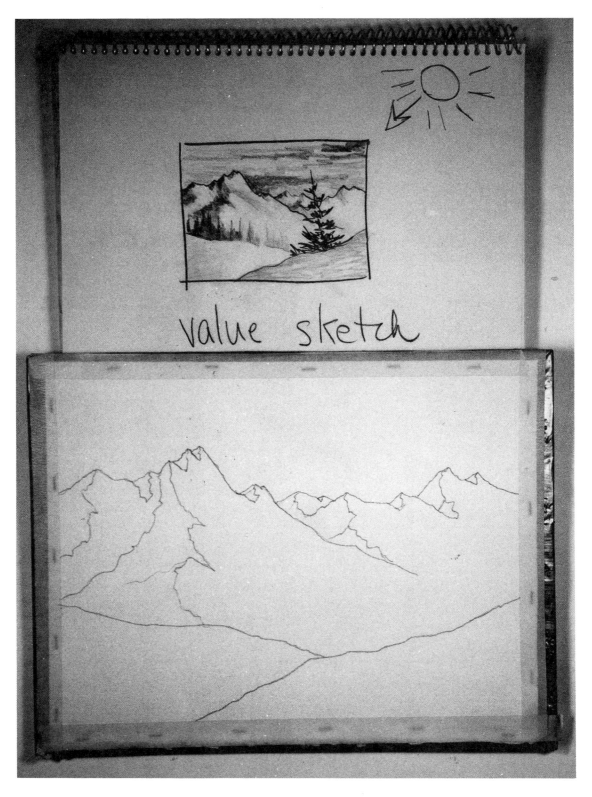

Figure 36

1. Transfer the value sketch into your sketchbook and place the line drawing on your watercolor paper (Fig. 36).

2. Prepare the following three mixtures, each to a consistency of light cream:

 • Rose Madder Genuine + Naples Yellow

 • Indigo + water

 • Cobalt Blue + water

3. Study Figure 37. With the 1" flat, wet the sky segment from the mountain line. Tip the paper to drain off excess water.

4. Immediately, while the paper is very wet, paint in the peach mixture; add Cobalt Blue in separate areas. Tip the paper to blend slightly (take just about 20 or 30 seconds for this action; you want the sky to be very wet when you add the Indigo. If you wait too long, the area will begin to dry and result in hard edges).

5. Add Indigo to the sky. Try to keep from making your shapes too scattered and spotty; this dark tone gives a directional sweep to the sky and helps define the mountains.

6. Blend the edges by tipping the paper. Dry.

7. Move two brushloads of the peach mixture to a clean place on the palette.

Notes

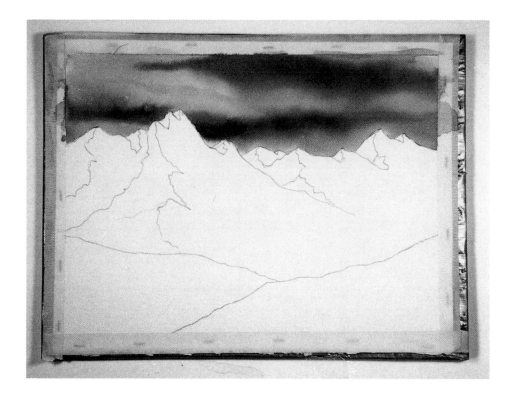

Figure 37

Notes

Add four or five brushloads of water into this new peach puddle, to a consistency of skim milk (light value, 8 or 9). With the 1" flat, paint this color from the top line of the mountains, covering the rest of the paper. Dry.

8. Basic Mountain Shadow: See Figure 38. Mix the three sky colors together to a soft mauve/gray, adding water if necessary to a midtone value of 5 or 6. Paint this tone on the shadow sides of each peak, blending down to a lighter shade at the foot of the mountain.

9. Light Side Contour: To add more detail

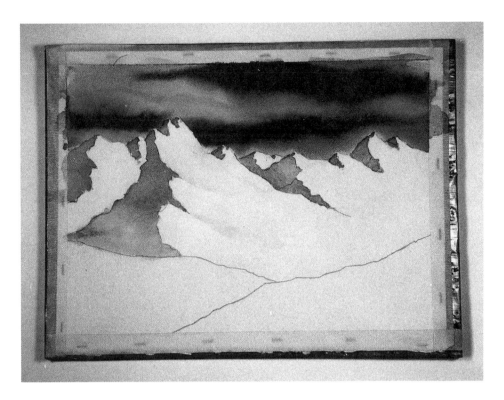

Figure 38

to the closest mountain, use the same shadow color and find likely places for ledges or cracks in the light faces of peaks. One at a time, with your rigger brush, paint a line of color and blend back toward the sky (See Figure 39). Dry.

10. Secondary shadow contour: Mix some Cobalt Blue with water to a light midtone (6). On the shadowed faces, paint additional contours as in Step 11 (Fig. 40). Dry.

11. If desired, erase the pencil lines on the mountain (if the lines are very dark,

Notes

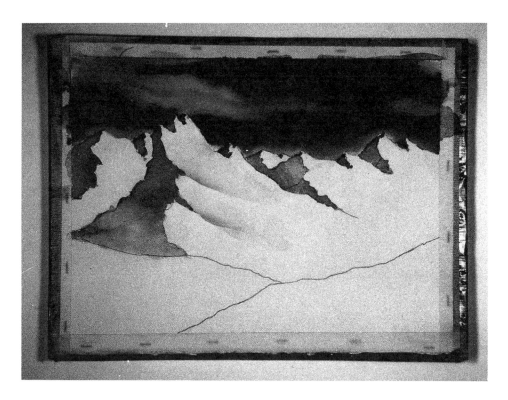

Figure 39

Notes

they may not erase completely).

12. Distant Tree Line: The distant trees will be smaller and lighter in value than the foreground tree. In this step, you'll also be defining the top edge of the distant snow bank by painting the bottoms of the trees even with the snow line. (Use the negative painting technique, painting right up to the snow line.)

Mix the following three puddles, each to a light midtone (7):

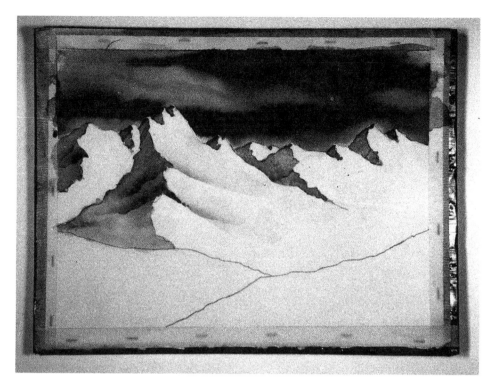

Figure 40

- Cobalt Blue + Peach Mixture

- Indigo + water

- Burnt Sienna + Cobalt, proportioned to a brown/gray

Notes

13. Study Figure 41. With the rigger, at the distant snow edge, paint a suggestion of tree line using each of the three puddles for variety. As you paint the trees towards the center of the painting, add water to fade them out to a lighter value. Think "groups of trees" rather

77

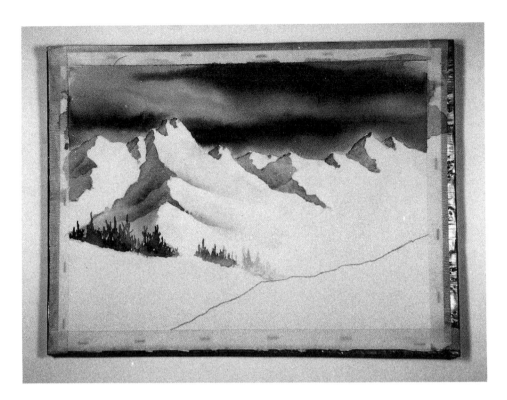

Figure 41

Notes

than individual ones - remember, you're trying to suggest trees that are far away. Again, avoid the picket fence effect by varying the size and shape of the groups and by leaving some space between groups. Leaving spaces employs the principle of "lost and found line" - the viewer's eye will complete the passage. Erase the pencil line that indicates the distant snow bank.

14. As the distant snow bank rounds away from the sunlight it would be in shadow (Fig. 42). Paint the shadow, starting at the bottom edge of the bank

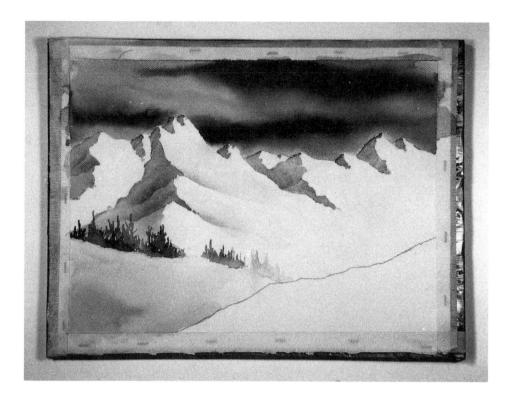

Figure 42

with the mountain shadow mixture, blended up for a smooth graded wash.

15. The foreground snowbank is curving away from the light source. Shield the top part of the painting, leaving only the foreground bank exposed. Paint the shaded bank with the same shadow mixture; while it's still wet, spatter in some peach color to warm it a little (Fig. 43). Salt the bank if desired. Dry.

Notes

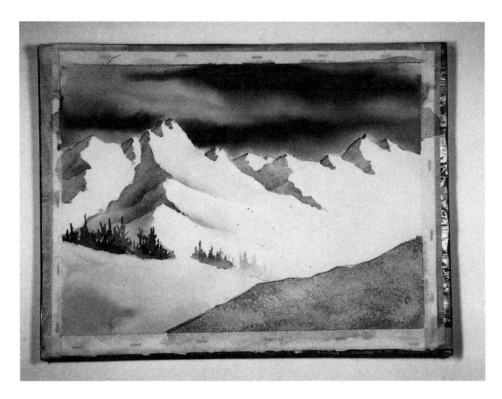

Figure 43

<table>
<tr><td>

Notes

Practice the entire foreground tree sequence in your sketchbook before painting it on your painting.

</td><td>

16. Foreground tree: Mix the following two puddles to a thick cream consistency:

> • Burnt Sienna, value 3
>
> • Indigo, value 3

17. Study Figure 44. With the rigger brush, paint the foreground tree with the Burnt Sienna color only. Let dry. This initial step will give the tree an underglow of warmth (Remember, foreground objects are generally warmer in tone).

18. With Indigo, paint over the first layer,

</td></tr>
</table>

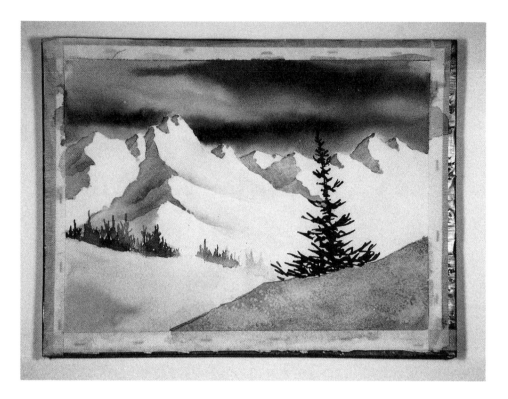

Figure 44

allowing some of the Burnt Sienna to peek through (Fig. 45). Let dry.

19. Using the same two colors and the rigger, paint some twigs in the snow. Dry.

20. With the shadow mixture, paint cast shadows from the twigs (Fig. 46). Let dry.

21. Shield the top part of your painting with paper towel pieces, leaving the foreground bank exposed. Sparingly spatter the dark colors on the bank, unifying the work and adding detail and interest to the foreground.

Notes

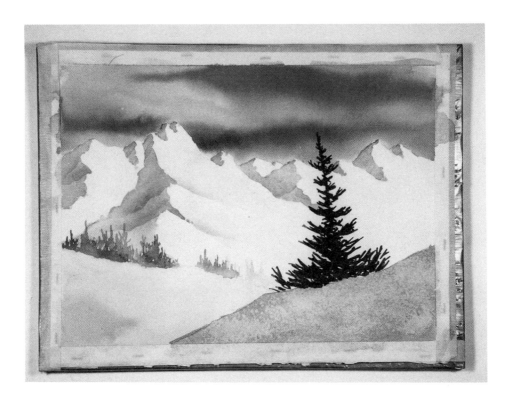

Figure 45

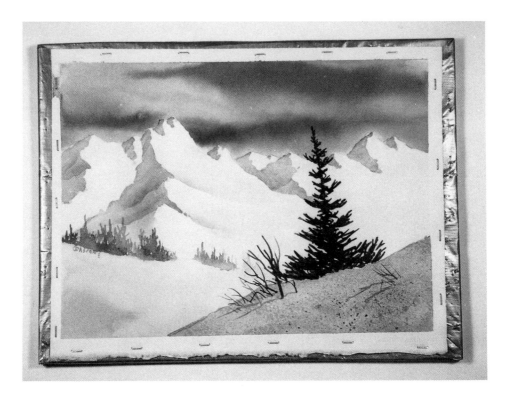

Figure 46

22. Sign the painting - step back and admire your work!

Notes

NORTHERN LIGHTS

Color Plate 6

The Northern Lights, or Aurora Borealis, as they snap with electricity and swirl across the night sky, are some of the most spectacular and dramatic lighting effects that one can paint. The red, blue-green and silvery white of the Aurora can be seen all over Alaska in the wintertime. More brilliant when seen away from the diluting effects of city lights, their appearance has been compared to layers of transparent undulating curtains. The Eskimos say that the Aurora are dancing spirits.

Having lived in Alaska all my life, I've seen the Northern Lights many times. My most memorable experience happened on a cold, clear night on the outskirts of Anchorage. My husband and I, with a group of friends, were leaving a social gathering at midnight. We heard a sound like static electricity, and looking up, were awestruck to see a transparent, multicolored curtain move across the sky as if blown by a stong breeze. We stood speechless, watching this flamboyant display for several minutes, until we were nearly frozen.

I'll always remember seeing the Lights in their full glory: the desire to capture their splendor and majesty made me experiment over and over for a suitable technique that would give me the best chance of success.

I wanted a soft-edged, brilliant sweep of color that was dramatically enhanced by the dark shape of sky around it; I think the process you'll be doing next achieves that goal. Most important for a successful completion of the sky is the consistency of paint used. The dark passages must be thick enough so that they don't overrun the lighter, thinner Aurora colors, but thin enough to give a soft edge. You may have to paint this piece several times before you're satisfied, but the results will be well worth the effort.

This lesson also details the procedure for painting spruce trees laden with fresh snow. You'll be using maskoid to protect the snow clumps from the dark sky washes, then removing the mask and painting the snow clumps. The spruce branches will be added last.

Colors Needed:

Rose Madder Genuine

Thalo or Winsor Green

Indigo

Burnt Sienna

Ultramarine Blue

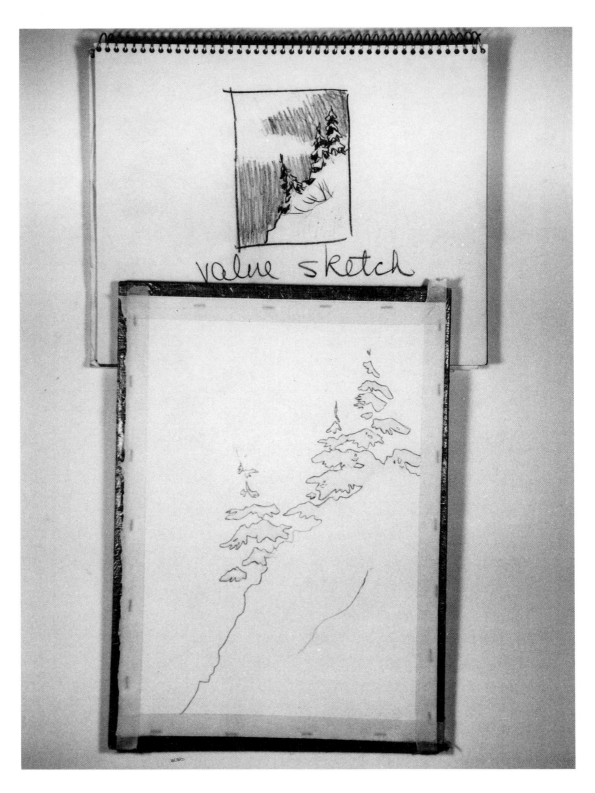

Figure 47

1. Transfer the value sketch and drawing as before (Fig. 47).

2. Review the instructions for applying maskoid in the definitions. Use the rigger to apply maskoid generously to the snow clumps on the spruce branches. Let the mask dry thoroughly.

3. Mix puddles of the following colors, to a consistency of light cream:

Rose Madder Genuine + water
Thalo Green + Ultra. Blue

Mix to a consistency of heavy cream:

Indigo + Ultra. Blue (use twice as much Indigo)

4. Study the Aurora shape in Color Plate 6. Wet the sky and drain off excess water, then lay in the first two mixtures one at a time, tipping the paper to blend the edges.

5. While the paper is still shiny (wet), paint in the Indigo mixture, defining the Aurora shape. Blend the edges by tipping the paper, but don't allow the Indigo mixture to engulf the Aurora. Tip the paper so that the Aurora has a lacy, soft lower edge (Fig. 48). Dry.

Notes

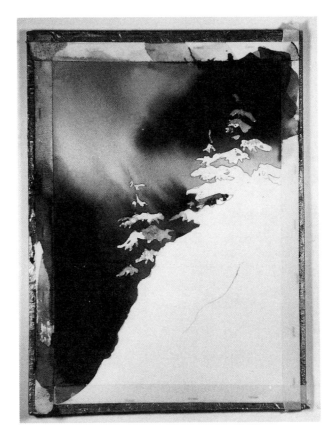

Figure 48

Notes

6. Prepare the following mixtures to the consistency of milk:

> Thalo Green + Ultra. Blue
>
> Rose Madder Genuine + water

7. Using the flat brush, wet the snow bank. Drain off excess water. One at a time, paint in the two mixtures, reflecting the green and red in the snowbank below their approximate position in the sky. Tip the paper to blend edges, and add salt for texture if desired (Fig. 49). Dry.

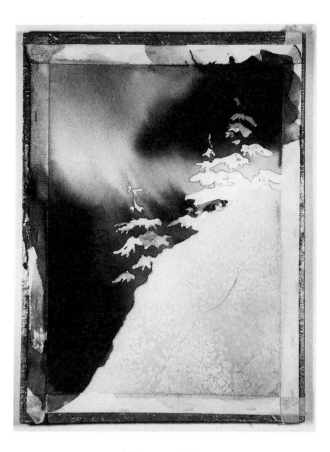

Figure 49

8. There's a line indicating a depression in the snowbank, about halfway down (Fig. 50). Using Ultra. Blue + water, value 5, paint a strip of color on the pencil line and blend it back with water, for a graded wash. Dry.

9. Remove the maskoid. With the rigger, carefully paint the snow clumps with either the green or red Aurora mixture, depending on what you used in the snowbank near the clump (Fig. 51). If you decided to use salt in the snowbank, use it again, for continuity. Dry.

10. The snow clumps are now "floating" in

Notes

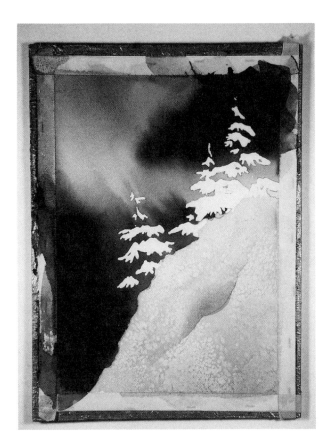

Figure 50

Notes

mid-air. Study Figure 52 to see how you'll connect them by painting in the exposed spruce branches and needles. Be careful not to paint an even fringe of needles around each clump. Vary the sizes, degree of extension, and shapes.

11. Prepare the following two mixtures, a bit thicker than the consistency of heavy cream:

Indigo + Thalo Green

Burnt Sienna

Use these two mixtures to paint the

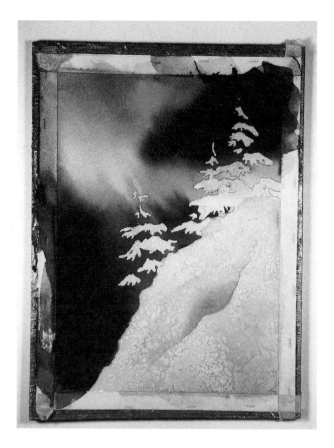

Figure 51

exposed trunk and branches of the spruce trees. Let them overlap, but allow each to show.

12. Paint some twigs near the depression in the snowbank, using the two spruce mixtures and the rigger (Fig. 52). Dry.

13. Use toothbrush spatter to soften the snowbank; sign the painting.

14. You've completed <u>Northern Lights</u>! The juxtaposition of dark against light, as well as the diagonal elements of the composition lend drama to this night scene. As a finishing touch, you might want to carefully pick out tiny specks

Notes

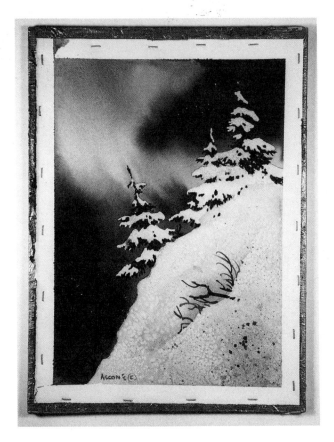

Figure 52

Notes

in the dark sky to represent stars. Use the pointed edge of a sharp razor blade. Remember, these marks are scars in the paper and cannot be camouflaged or painted over; once you've created them, they're in the scene forever. So use caution.

WILD IRIS

Color Plate 7

For a change in subject matter, I've included this floral composition. The Wild Iris, or Blue Flag, grows in abundance in marshy areas around Southcentral Alaska - it's one of the first wildflowers that bloom in the spring. Wild Iris is also common in flower gardens here. The model for this particular bloom was photographed on the shore of Big Lake, Alaska.

In this painting, you'll employ a black watercolor marker pen to give the piece a graphic, poster-like effect. A soft-edged background will complement the sharply-focused main flower, which will be further highlighted by outlining with the marker.

Read over the entire section before beginning.

Colors:

Aureolin Yellow

Ultramarine Blue

Alizarin Crimson

Thalo Green

Burnt Sienna

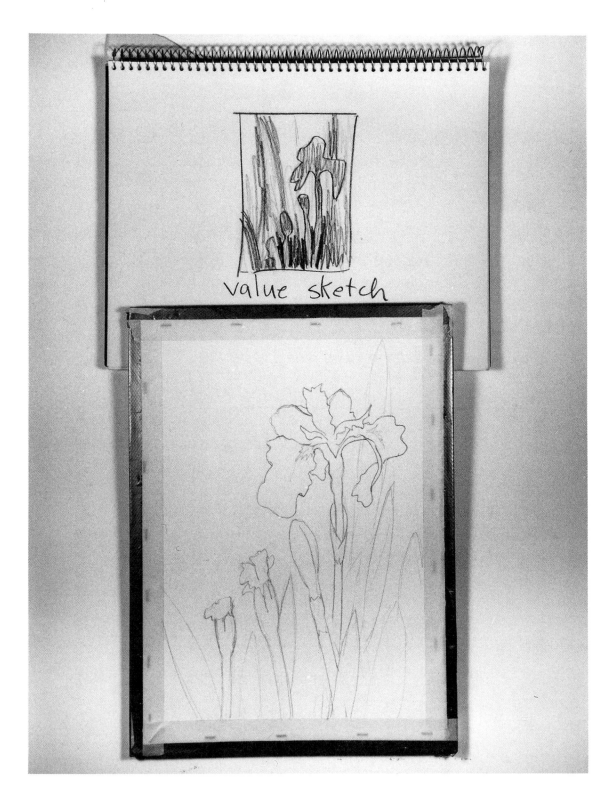

Figure 53

1. Transfer the value sketch and drawing (Figure 53).

2. With a generous application of maskoid, protect the Iris bloom, down to the joint at the flower's base. Mask the petal parts of the buds. Let the maskoid dry thoroughly.

3. Mix light midtones (skim milk consistency) of the following colors:

> Ultra. Blue + Alizarin Crimson
>
> Thalo Green + Alizarin Crimson
>
> Burnt Sienna + water
>
> Aureolin + water

In a separate puddle, mix a midtone of:

> Thalo Green + Alizarin Crimson

4. Wet the entire paper and drain off the excess water.

5. Paint a random vertical pattern of the light midtone colors, covering the entire paper. Place the yellow so that it will appear behind the main blossom. (You're playing complementary colors off each other here. Yellow is the complement of purple, so the tones of purple in the blossom will show up vibrantly in contrast.) Tip the board to blend the colors (Fig. 54).

Notes

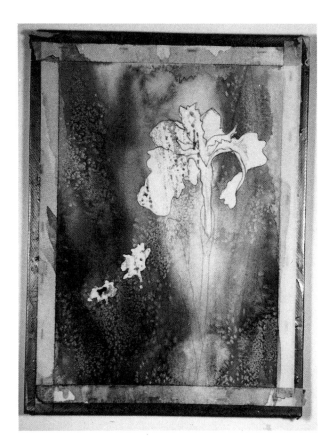

Figure 54

Notes

6. When the paint has lost its shine but is still damp, use the spray bottle to lightly sprinkle drops of water onto the wash. Be sparing in your use of water, watching carefully after each stroke of the plunger. Lift the top edge of the painting so that the drops "run" a bit in a vertical pattern. This will cause blooms, or backruns, to give a washy, textural effect to the background.

7. While this wash is still damp, add a few leaf shapes with the darker green mixture. Be careful not to overwhelm the initial wash. Carry one or two up out of the top of the painting for

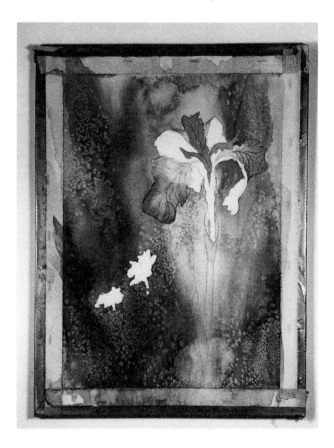

Figure 55

compositional balance. When the dark leaves begin to lose their shine, sprinkle a bit of salt over them (Fig. 54). Dry.

8. Remove the mask from the painting. Prepare midtone mixtures of the following colors, the consistency of milk:

> Aureolin + water (for centers)
>
> Ultra. Blue + Alizarin Crimson

9. See Figure 55. Paint the top surfaces of

Notes

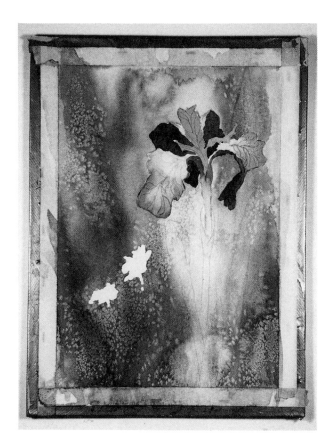

Figure 56

Notes

the outer Iris petals one at a time:

Moisten the petal. Lay in yellow and blend it out in a graded wash to about 1/4 the length of the petal. Dry.

Lay in the purple mixture at the end of the petal, and blend it up to the yellow, letting the wash overlap a bit. Scrape dark veins while the paint is still wet, using the chisel end of the brush or another scraping tool. Dry each petal before continuing.

10. Inner petals: Add a bit of Alizarin Crimson to the purple puddle and paint the inner petals (Fig. 55). Dry.

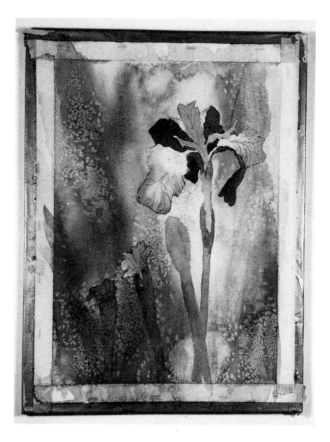

Figure 57

11. Mix a puddle of dark midtone:

> Ultra. Blue + Alizarin
> (use more blue this time)

12. Paint the back surfaces of the petals with this mixture, blending the color out as you reach the stem. Scrape veins and dry (Fig. 56).

13. Paint the emerging bud petals with your choice of petal mixtures. Scrape veins and dry.

14. Add a bit of water to the darker green

Notes

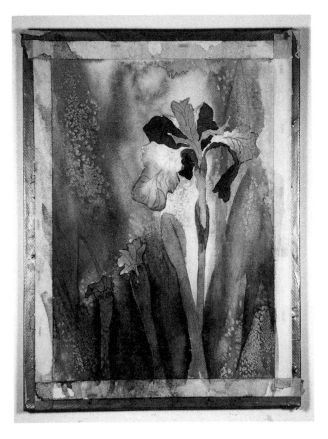

Figure 58

Notes

mixture, and paint the stems and green buds. On the main flower stem, as you reach the blended purple of the flower, blend out the green to form a smooth join of colors (Fig. 57).

15. Mix a small amount of Burnt Sienna + Ultra. Blue to a brown tone. Paint the "cup" that holds the top section of the stem with this mixture, blending it into the green stem (Fig. 57). Dry.

16. Next, you'll be adding complexity and interest to the lower background. Study Figure 58. Study your own painting and draw in various leaves that will be

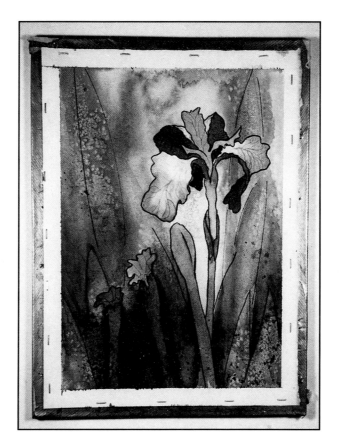

Figure 59

negative-painted, leaving them light next to the dark background.

17. Use the green mixture to negative-paint these leaves and the bottom parts of the main stems, blending out the color about a third of the way up the painting. Dry.

18. It's time to define edges graphically, with the watercolor marker. Study Figure 59 and outline the petals, leaves, stems, and buds.

19. Spatter some color into the background - then sign and admire!

Notes

Color Plate 1. <u>Beach Ball with Shadow</u>

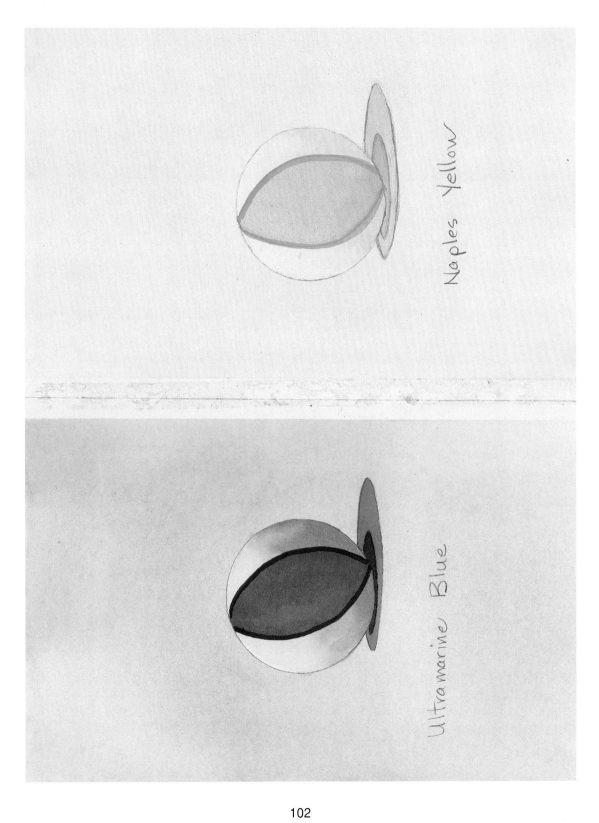

Color Plate 2. <u>Snow and Forest</u>

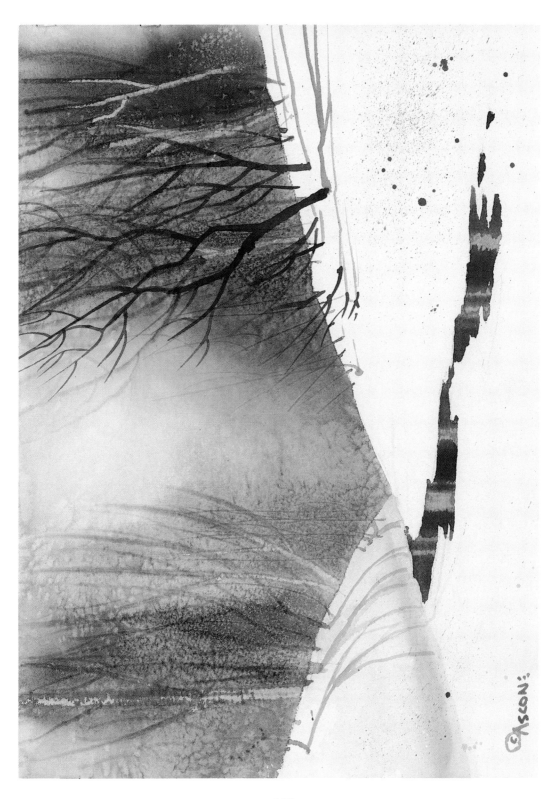

Color Plate 3. <u>Winter Birch</u>

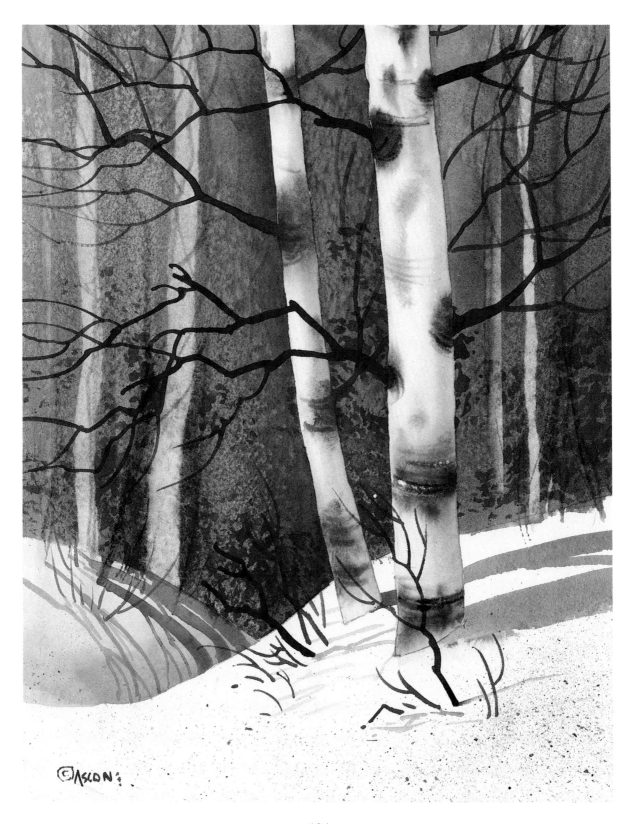

Color Plate 4. <u>Cliffside - Turnagain Coast</u>

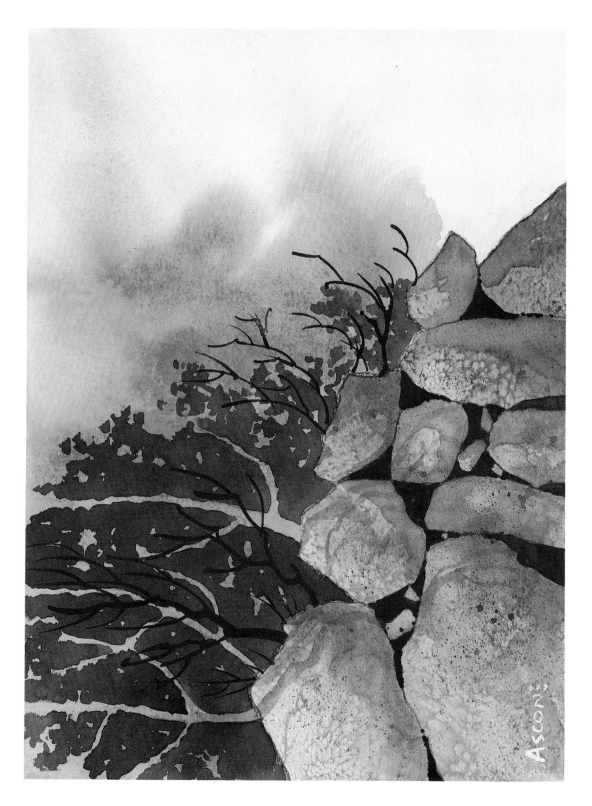

Color Plate 5. <u>Snow Covered Peaks</u>

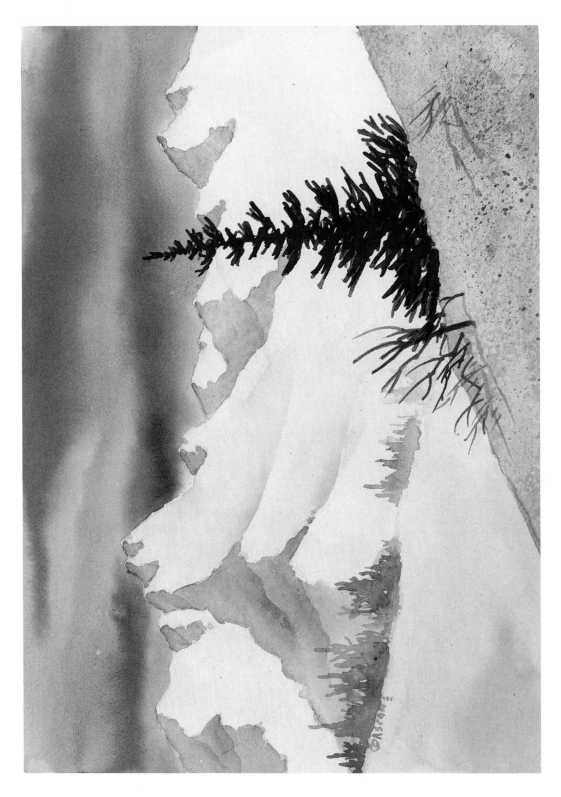

Color Plate 6. <u>Northern Lights</u>

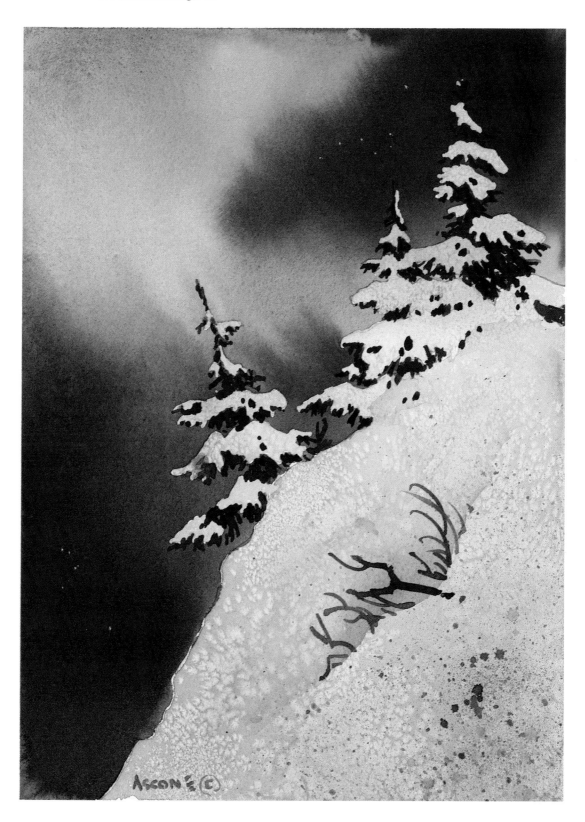

Color Plate 7. <u>Wild Iris</u>

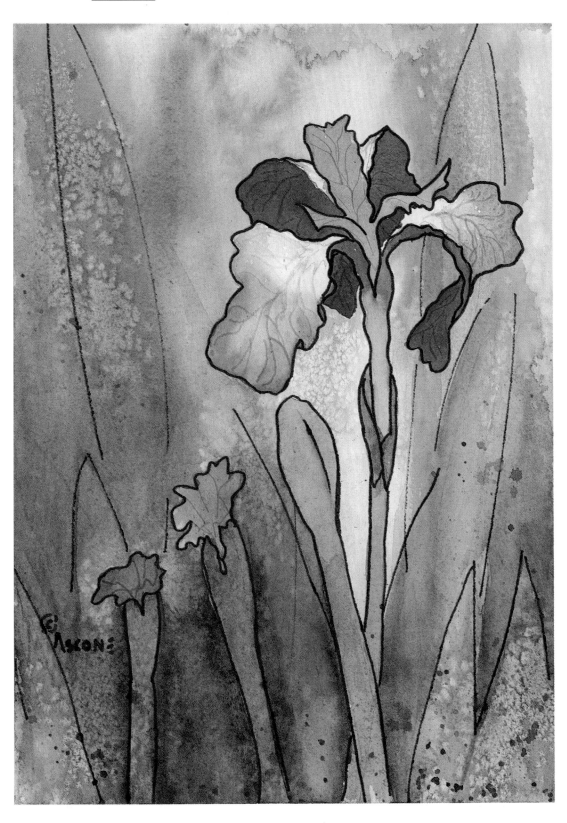

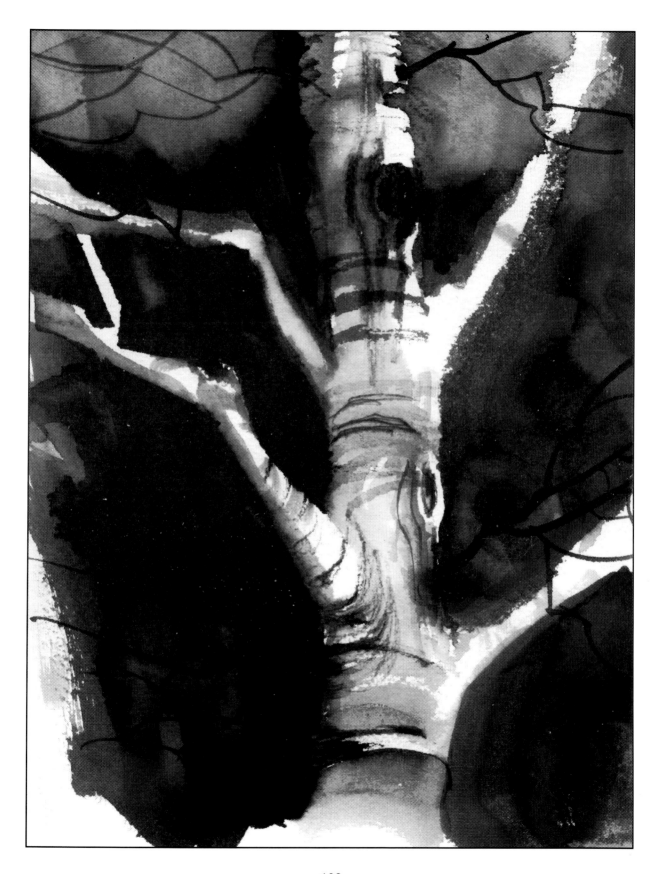

*"Imagination is the highest kite
one can fly."*

- Lauren Bacall

CHAPTER FIVE

PERMISSION TO PLAY

ALLOWING THE PLAYFUL SELF TO EMERGE

You may not be aware of it, but you've been robbed.

Stop! Don't rush to check your wall safe or jewelry box; I'm talking about being robbed of something that could be more valuable than money or jewelry: the natural process of expressing yourself. There's no one person to blame, and there's only one person who can retrieve this process for you. That's right - YOU.

Why did it happen? I believe it's because of Western society's incessant search for excellence. We get the idea that only the best and the most obviously talented of us have the right to paint, dance or sing. We're embarrassed. Competition winnows out everyone but the most proficient or "gifted."

Take, for example, the Olympic games. Hundredths of a point separate winners from "losers." Others are allowed only to watch while the most excellent ones express themselves.

Don't misunderstand - there's nothing wrong in striving to be the very best you can be. But sometimes we carry this idea too far, especially when ordinary folks begin to feel left out, and more significant, feel they SHOULD be left out because they aren't "good enough" to participate. There's room for all kinds of expression, from everyone, no matter what level of ability. We're all artists. In olden times, everyone

in the village felt able to get up and move to the dances learned by heart, or sing the traditional songs. This happens today in Eskimo villages, where everyone from age two to seventy-two gets up and dances to the best of his or her ability. All are welcomed. No one is excluded for lack of "talent."

"In every human being there is the artist, and whatever his activity, he has an equal chance with any to express the result of his growth and his contact with life. I don't believe any real artist cares whether what he does is art or not.
Who, after all, knows what is art?"

- The Art Spirit by Robert Henri

We do not lose the ability or the desire for play. What we lose is permission from OURSELVES to spend the time and energy doing something "useless" or "non-productive." We are a goal- and product-oriented society, many of us driven to spend our time in pursuits that result in something measurable by one of the only measurements respected: money. If a pursuit can't be linked somewhere down the line to financial gain, we deem it unworthy of "wasting" our time.

"Many of Picasso's contemporaries and friends report that he felt wholly alive only when he was painting. Only then was it possible for him to escape the lethal compulsion to ACHIEVE and instead to taste the freedom of inspiration, feeling and impulse - that is, of life."

- The Untouched Key by Alice Miller

Of course, we need a certain amount of money to live - we must be concerned with earning it to put a roof over our heads and food on the table. But playtime, like laughter, is also essential, part of what makes us human; play is necessary for a balanced life. Playtime releases stress, increases happiness, replenishes vitality, and helps us access the creative parts of our brains. It takes us to a serene place of restfulness, and gives us relief from day-to-day anxieties. As dancer Twyla Tharp said, "Art is the only way to run away without leaving home."

Playing with paint, without an objective in mind, allows the carefree spirit to come forth. There's something about non-verbal, visual expression that helps us experience true delight, empowering the spirit in a deep, visceral and joyful way.

The impulse to create images is an innate human quality - art is our first language. Remember yourself as a child tracing images on a frosty window, making marks in the sand, or creating mud sculpture? Sometimes, what cannot be said in words can be expressed in art. In fact, searching for the "right" words can sometimes hinder the natural process of expression.

Studies have been done that identify certain kinds of activities with the "left brain" or "right brain." The left side of the brain allows expression of linear, logical thought, such as speech, or mathematical concepts; the right side of the brain handles creative, intuitive, non-linear, non-verbal concepts. My own experience illustrates the theory: when I'm painting in a classroom, I have to either paint or talk - I can't do both at the same time. Even though I've had lots of practice teaching painting techniques, I continue to experience this "far away" feeling as I paint. Often, while I'm demonstrating a technique, my words don't match what I'm doing - I'll notice people watching me in puzzlement or someone will correct me; "You said right, don't you mean left?" or, "You say red, but you're using blue." My words don't make sense because verbal skills are hard to reach from the right brain. So, I must stop painting to explain the the technique in words.

Achieving a balance between work and play, between left and right brain activity, is essential for a well-rounded life. Reach for that balance by allowing your own creative side to re-emerge. On the next page I have listed steps to help you over the "left-brain hurdles" that may impede the path to creative expression.

HINTS FOR PLAYTIME

• Play non-intrusive instrumental music as a relaxing background.

• Don't be afraid to use your fingers. I once saw a man demonstrate finger painting; he used his closed fist, fingers and fingernails, even his forearm, to make different marks on the paper. Try it. Get some Hot Pressed (smooth) paper, so the details of different imprints will show up well. The artist Chuck Close made a giant self-portrait, using a grid containing hundreds of his own thumbprints in a pattern of light and shadow. Prehistoric cave painters used blow guns to paint silhouettes of their own hands.

• Did you ever relax in a grassy field, studying clouds to imagine shapes? Try to get to that unhurried place in your mind, imagining shapes in the watercolor as you play.

• Try wetting a large sheet of paper and floating pure colors on it, letting them blend and swirl where they will. Study the shapes that emerge when you tip the paper in different directions.

• Load a big brush with color and throw the paint off the brush onto wet paper. Don't have a plan, just see what happens.

• With great energy and abandon, use your fingernails, brush end, or other tools to scrape marks in the color. Draw stick figures, grass, or other simple shapes. Sprinkle a little salt around, use the spray bottle to see what happens.

• Above all, DO NOT be critical or judgmental towards the art that results from this playtime. Even if you don't like what you produced, don't be tempted to think of the time as wasted. The process is important here, not necessarily the product.

"One reward for sketching is that you learn to 'see.' This gives you a very rich source of entertainment for the rest of your life."

- Ed Whitney

CHAPTER SIX

DRAWING TO PAINT

There are many different kinds of drawing, and an endless array of tools for the job. From pen and ink on fine parchment to charcoal on newsprint, drawing is one of the most ancient and natural methods of visual communication. The impulse to draw is innate in humans. Whether it's drawings on cave walls, a stick tracing images in the sand, or doodles on a restaurant napkin, the impulse begins from the time we are very young - think of the years spent affixing our children's drawings to the refrigerator door!

You can paint without preliminary drawing of any kind, by using the brush and paint as you go along. But sometimes you'll want a specific guideline for your painting. Suppose you want to draw a collection of treasured objects, but end up with the relative proportions all wrong? Perhaps you intended to include several objects, but discover by the time you've drawn one, there's no room for the others. Or maybe you finally get the proportions right, but the paper is scarred by numerous erasings. A method of drawing that avoids all of the above problems would come in handy at times like these - a specific kind of drawing that allows for more accurate representation.

The process of turning a life-size, three-dimensional scene or object into a two-dimensional drawing that will fit on your paper can be simplified into a dependable formula. Because the drawing is the foundation, not the final technique needed to fulfill the painting, shading is not desired - essentially, what is needed is a line drawing. The method described in this chapter works to achieve this. By using the searching scribble-draw line to achieve proportions and assigning a format in preliminary steps, the tender watercolor paper is spared the wear and tear of erasing.

To become acquainted with this method of drawing, I recommend that you choose very simple subjects to draw at first, so that you can become familiar and comfortable with the process. Some appropriate beginning subjects would be:

a vase

a cup

bottles

a hat

a shoe

a boot

a soup can

a spouted pitcher with handle

a pineapple

The first dozen or so drawings you do should be uncomplicated. Take them through the steps to the finished line drawing stage. Then, as you get used to the method, gradually introduce more complex subjects.

SUPPLIES NEEDED FOR DRAWING TO PAINT

sketchbook, approximately 11" x 17"

tablet of tracing paper, approx. 11" x 17"

2 common pencils, No. 2

ball point pen, red ink

medium point black felt tip pen (for grids)

kneaded eraser

18" ruler

Once you've collected the supplies, you're ready to begin. The first, most important step is:

Figure 60

TAKE YOUR TIME.

THINK AND OBSERVE.

1. See Figure 61. You'll make your scribble-drawing the same size as the line drawing you'll want on your watercolor paper. To begin, start with a No. 2 pencil and your sketchbook. Remember to take your time - you're not in a race!

2. Let your eyes drift over the object to absorb the general appearance.

SCRIBBLE-DRAW

Figure 61

SCRIBBLE-DRAW.

3. Allowing your hand to be free and relaxed, begin to LIGHTLY make scribble marks on your paper in the rough shape of the object. Don't be concerned with details at this stage. You're after a scribbled web, forming an approximate silhouette of the object, with roughly correct proportions. Don't erase: just keep searching with your lightly scribbled line to catch the shape of the object.

LOOK.COMPARE.CORRECT.

4. Look at your rough drawing. Study the object, and compare the two. Look at it upside down; reflect it in a mirror; errors are sometimes more apparent from a different angle.

5. Correct any glaring errors with a darker line.

> Note: If you're uncertain of relative proportions, hold your pencil at arm's length (keep your arm straight) and sight along your arm, closing one eye. Holding your pencil as a measuring stick, line up the eraser end with one edge of the object, and mark the length or width on the pencil with your thumb. Then compare with another dimension on the object to check the size relationship of, say, the length to the width.

CORRECTING OUTLINE

6. Use your pencil to outline the scribbled drawing. Make appropriate marks to indicate details to be included in the painting. As you draw, keep checking the object to compare.

ADJUST OUTLINE

7. If the proportions of the drawing seem wrong, make adjustments with a darker line. Erase if necessary.

TRACE OUTLINE

8. Take a sheet of tracing paper and trace the corrected outline with the pencil. Re-evaluate the drawing and refine it by making small corrections on the tracing paper. Carefully add more detail if needed; this corrected tracing is what will actually appear on your watercolor paper as the basis for your painting.

TRANSFER

9. Turn the traced drawing over, and go over the lines with your pencil, shading the reverse side of the drawing.

10. Carefully place the drawing right side up on your watercolor paper, taping the edges with a bit of masking tape to hold it securely. (Don't move it around during placement, as the graphite will smudge the paper.)

11. Using the red pen, trace over the lines so that the graphite transfers the drawing to your watercolor paper. Carefully remove the tracing paper; your drawing is neatly in place, without messy erasures, and ready to paint.

ENLARGING A DRAWING

Simple grids can be used to enlarge your drawing. (They can also be used to enlarge and transfer a photograph for painting; see Fig. 64) After your drawing is worked out in the sketchbook, follow the steps below to transfer it to your painting format. Use tracing paper and the black felt tip pen to make the grid lines.

Figure 62

1. Make a small grid to enclose your sketch on tracing paper: first, draw a rectangle that will enclose the small sketch.

2. Follow the steps in Figure 62 to construct the grid.

3. Take another piece of tracing paper and make a large grid the same proportions and angles as the small one, that will fit on your watercolor paper. It must be the same proportion as the sketch grid; if you try to make a square sketch fit a rectangular format, it won't work, the proportions will be off. (On the other hand, you could deliberately skew the proportions for an original, fresh look at the subject matter! But for our purposes, we'll assume you want the subject matter to be representational.)

4. Place your sketch grid over the sketch and study it. Notice where each element appears through the grid.

5. Carefully transfer the sketch by drawing each element in the same, or corresponding section on the larger grid, Figure 63.

6. Turn the large grid over and rub your pencil lead over the back of the drawing. Transfer the drawing to your watercolor paper as described in the previous section.

REMEMBER:

1. Small mistakes will be magnified as you enlarge.

2. Practice - there is no "magic" method of improving your skill.

3. Start with simple shapes - do ten drawings of different subjects.

4. Try doing combinations of shapes, such as in a still life, by overlapping traced sheets to build a new painting. (Pay attention to relative sizes of objects.)

5. Watch your proportions, both in drawing and in grids when you transfer.

6. Use a LIGHT touch in the searching scribble-draw - keep it "negotiable."

7. Use your sketchbook to draw something every day! The more you draw, the better your paintings will be.

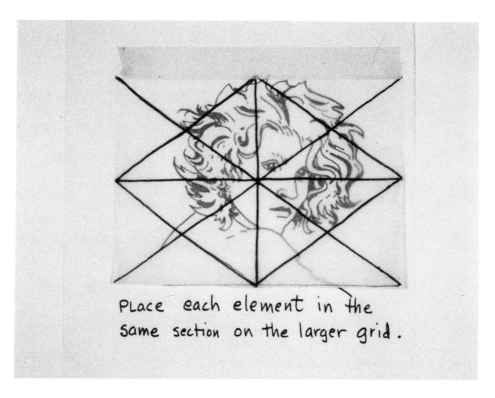

Figure 63

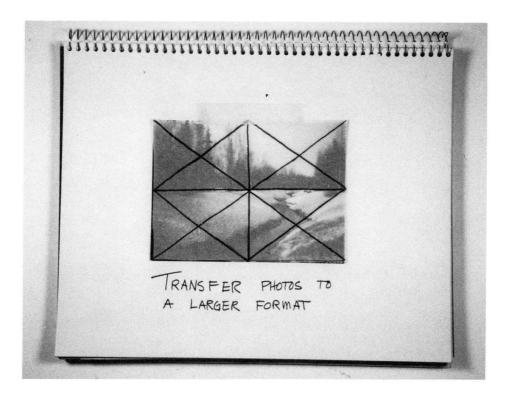

Figure 64

"There can be no such thing as 'too much' art. Undoubtedly in a rational society everyone will be creative. Everyone will produce art in some way."

\- <u>Start Over Every Morning</u> - by Harvey Jackins

CHAPTER SEVEN

PAINTING ON YOUR OWN

PAINTING ON YOUR OWN

If you've painted your way through the first sections of this book, you have the tools and techniques at hand to start painting on your own, using compositions, color selections, and subject matter that you choose. It's helpful to experiment with different papers and colors, take workshops from different teachers, and gather information from books. As you explore, you'll begin to develop your own style of expression; it's exciting to see that happen! On the next page is a checklist to help you on your way.

Checklist for a successful watercolor

1. When choosing your painting subject, decide what attracts and excites you about the subject matter. What do you want to emphasize, or perhaps exaggerate, to also excite or involve the viewer?

2. Do several quick thumbnail value sketches. Try reversing values, changing formats (vertical, horizontal, round, oval) to see which choice produces a more effective composition.

3. Decide on a format and complete a larger value sketch. It can be helpful to reflect the sketch in a mirror, or view it upside down to check balance. Use the following questions to analyze the sketch:

 a. Is there a center of interest, well estabished?

 b. Is there a good balance of darks and lights, with one predominating? Do the darks and lights connect in an interesting pattern of interlocking shapes?

 c. Are there midtones?

 d. Does most of the main action occur away from edges, corners, and the exact center? Too much going on in these areas can draw the eye out of the painting.

 e. Watch for the picket fence effect: elements too much the same size or spacing.

4. Choose a color scheme. Is it in keeping with the mood or season of the subject? Is there a balance of warm and cool colors, with one temperature predominating? It can be helpful to dab chosen color swatches beside your value sketch.

5. Transfer the drawing to your watercolor paper.

6. Plan the order of your painting; make a list. Do you have white areas to save or mask? Is it important to establish a dark early on, to bracket your value range? What needs to be painted first?

7. Begin painting. View the painting from a distance several times during the process to check development of the work.

8. When large shapes are established, place the painting in a mat and make a list

of what it needs to be finished, or what corrections or adjustments are needed. Take your time, relax during this process.

9. As you finish the painting, view it from a distance often to keep from adding too much "frosting" or detail.

*"A healthy artistic climate does not depend solely
on the work of a handful of supremely gifted individuals.
It demands the cultivation of talent and ability
at all levels...The pursuit of excellence is a proper
goal, but it is not the race itself...."*

- Gough Whitlam

GALLERY

See how many techniques you can identify...

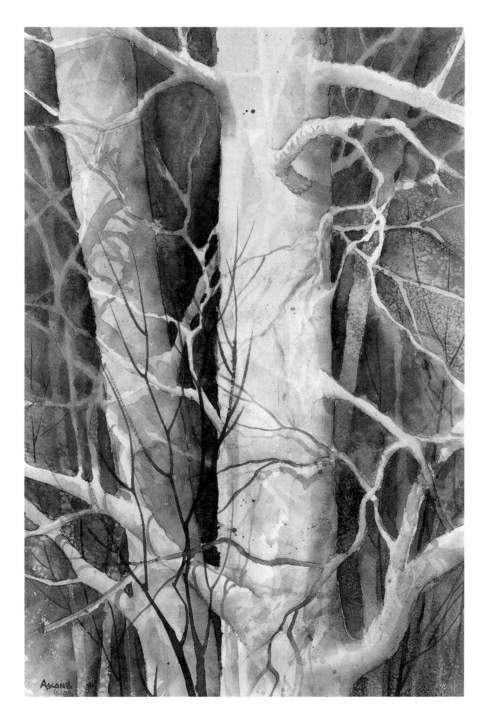

Shadowplay

Fractured Fowl

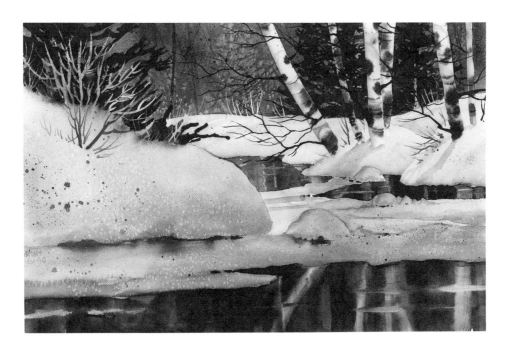

Afternoon Shadows

Light Patterns

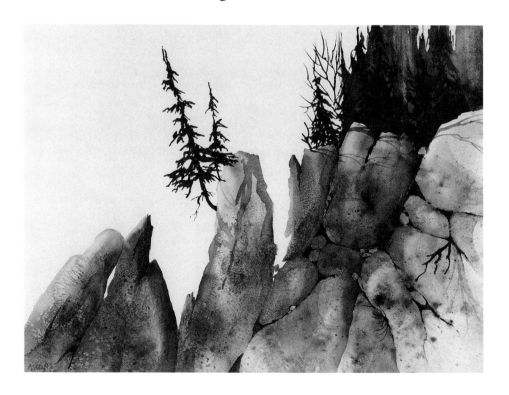

Survivors

Heigh, Ho!

Down at the Docks

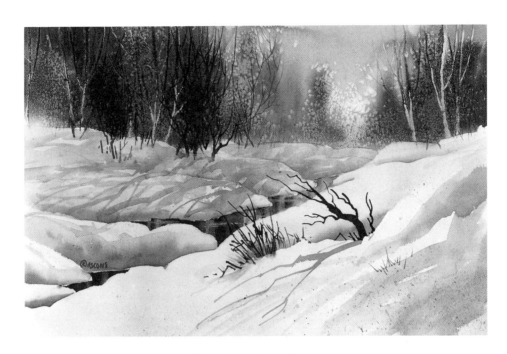

Near Hatcher Pass

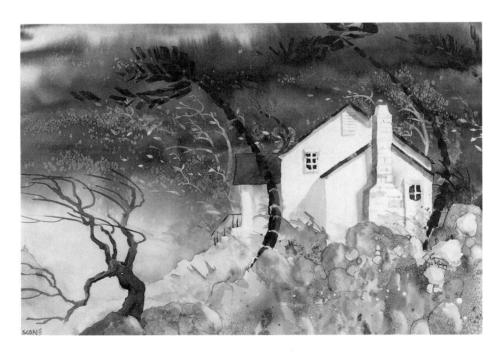

Kahului Storm

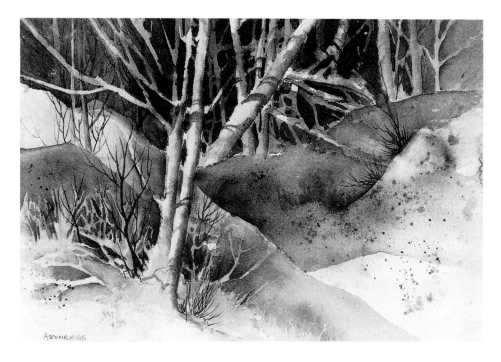

Forest Tangle

Molly - Drifting and Dreaming

City Fish

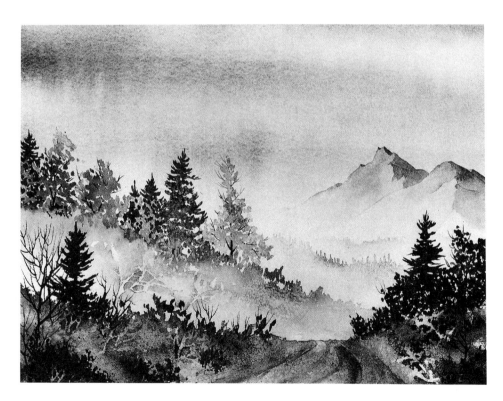

Sunday Drive

AFTERWORD

This book is not intended as an encyclopedia of watercolor painting, but as a beginner's guide that will give you a few tools and techniques to begin your own artful journey. If I have succeeded in capturing your interest, and have convinced you that you will enrich your life by tapping into that creative stream that we all have access to, then I'll consider this book well worth the effort.

The lessons contained herein reflect my particular style of painting. By no means do I wish to imply that my way is the ONLY way, or that other styles aren't just as worthy and "correct." You must follow the path where your heart leads. All artists do.

I hope you will find this book useful, and I encourage you to write to me and let me know of your personal experiences in painting. We can all learn from one another.

Write me in care of:

Alaskan Portfolio Press
P.O. Box 241453
Anchorage, AK 99524-1453

Teresa Ascone conducts workshops in Alaska and elsewhere. If you'd like to inquire about her workshop schedule, write for information:

Teresa Ascone Workshops
c/o Alaskan Portfolio Press
P.O. Box 241453
Anchorage, AK 99524-1453
(907) 272-2070

ORDER FORM

> Send to: Alaskan Portfolio Press
> P.O. Box 241453
> Anchorage, AK 99524-1453

Your name:_____

Address: _____

BOOK: We're All Artists: Watercolor for Everyone: $19.95

VIDEO: Landscapes of the Imagination: The Art of Teresa Ascone: $19.95
Award-winning 28 minute video produced by KAKM Public Television, produced and directed by Eric Wallace. Guides the viewer through Teresa's research in the field and work in the studio, demonstrating many of her techniques and her philosophy.

T Shirt: While supplies last. Short sleeves only. 50% polyester, 50% cotton, Full color "We're All Artists" book cover illustration on front. White only. $15.00

Apron: While supplies last. 50% polyester, 50% cotton. Full color "We're All Artists" book cover illustration on white background, two pockets $15.00

Book:____copies @$19.95 =	_____
Video___copies @$19.95 =	_____
Book/Video set:____sets @ $36.00 =	_____
T-Shirt: specify S, M, L, XL @$15.00 =	_____
Apron - one size fits all @$15.00 =	_____
Shipping: $3.50 per item:	_____
Total enclosed (check or money order*):	_____

*Please make payable to Alaskan Portfolio Press. (No C.O.D.)
Items shipped within three days of receipt of order.
Photo copies of this form are acceptable

A portion of each book sold will benefit the Burn Treatment Unit at
Providence Hospital, Anchorage, Alaska.

Comments from students:

"As director of the program for which Teresa teaches, I request student evaluations for each class taught. Student evaluations... have been very positive and include comments stressing Teresa's professional approach to sharing her expertise...her teaching methods include 'demonstration of techniques, relaxed positive approach, and encouragement' of students and provide a 'good introduction' in a 'wide variety of techniques.' She is praised for her 'willingness to answer questions' and her 'positive support'...As a student in Teresa's Intermediate Watercolor Techniques class, I was pleased with not only her wonderfully professional style in sharing her considerable expertise, but with her friendly, warm manner as well. She encouraged me to experiment and make my paintings my own personal expressions of myself. I thoroughly enjoyed her class and intend to take another class from her in the near future."

- Alice Dionne, Director
Downtown Center
UAA College of Community and Continuing Education

"...From Day One Teresa has you painting..."

Kelly Leslie, student

"...Teresa is a great teacher - the classes were EXCITING and FUN!! She makes each step seem easy, and all of a sudden there is a beautiful result!...Teresa generously shares her knowledge with enthusiasm and great skill"

Darlene Crawford, student

"I found Teresa's technique for teaching watercolor very clear, and much to my surprise, easy to master. Her sense of not only watercolor painting, but of art, composition, use of color and love of nature was included in each lesson. It was rewarding completing paintings in only a few classes. I continue to paint today using many of the techniques I learned from Teresa."

Stephnie "Stevie" Russell, Free-lance Graphic Artist

"Not all artists are good teachers - Teresa has a unique ability to make you feel like you can create art..."

Jan Adams, student

"...The classes I have taken from you have enriched my painting experience. You have been willing to share your knowledge and techniques in a very easy to understand method. Your workshops are among the most productive I have taken. You helped give me confidence..."

Jean Stamper, Owner
Stamper Inn, Seldovia

"Teresa has empathy. She enjoys teaching and is generous in sharing. With a pleasant and easily understood voice, she talks her students through the painting process...Everyone comes through feeling success."

Rachel Harris, retired school teacher

"Teresa holds back nothing! She has a lot to share and shares it all! Some people can paint and some can teach. Teresa is a very gifted artist who also has the skill to pass it on to others. Teresa's method of instruction allows one to follow along, step by step, and then take those steps and develop one's style... Having studied under Teresa, I have become an accomplished artist."

Suzanne Bach, Interior Designer

"Teresa is positive and inspiring...I always completed her classes with a feeling of accomplishment."

Becky Whitney, student

"I was forty-nine years old when my wife encouraged me to take a watercolor class through our local community college. I was pleasantly surprised to find I could create modest pictures depicting the Alaska I so loved. That was the beginning. Many classes have followed including two packed classes taught by Anchorage artist Teresa Ascone. Teresa, with her homespun, 'Let's go into the kitchen and create something beautiful' style, left me saying 'I can do that.' Today this one time builder, bush pilot, oil field welder, charter skipper, finds himself sharing his life and times through this media of 'Paint.'"

John Fenske, student

"The last thing I thought that I had was any talent for art. After being a professional nurse for thirty years, raising four children,...and becoming a pilot, I became interested in art...Teresa has the unique ability to share her knowledge, yet inspire and encourage the learner at any level. She

is very non-threatening in her teaching style. Eventually I took three workshops from Teresa and each time I learned so much!...Teresa's classes are fun and great learning experiences...[she] helps each person in her class to recognize something positive and good and creative in themselves."

Donna Fenske, Itinerant Public Health Nurse

"Rather than just showing me how to paint a picture, Teresa taught me valuable techniques. Without any other artistic training, I now use her methods to create paintings that are truly my own."

Anthony J. Route, Author

"...As usual, the members were rushing to register for your workshop. I told one of the artists that you were coming to teach and the class was filled before we had finished printing the newsletter which advertised it..."

Karen S. Glavinec, Program Coordinator
Anchorage Senior Center

"Thank you so much for the wonderfully professional workshop you prepared for the Dillingham Arts Council. Everyone was so impressed with the amount of material covered and your expertise. Your teaching techniques showed careful planning and knowledge of a student's ability to grasp material presented. We all left feeling a great deal of respect for your talent and your capability of sharing the joy of watercolor."

June Cherry, Director
Dillingham Arts Council

Index